THE FOCAL EASY GUIDE TO

FLASH MX 2004

The Focal Easy Guide Series

Focal Easy Guides are the best choice to get you started with new software, whatever your level. Refreshingly simple, they do not attempt to cover everything, focusing solely on the essentials needed to get immediate results.

Ideal if you need to learn a new software package quickly, the Focal Easy Guides offer an effective, time-saving introduction to the key tools, not hundreds of pages of confusing reference material. The emphasis is on quickly getting to grips with the software in a practical and accessible way to achieve professional results.

Highly illustrated in color, explanations are short and to the point. Written by professionals in a user-friendly style, the guides assume some computer knowledge and an understanding of the general concepts in the area covered, ensuring they aren't patronizing!

Series editor: Rick Young (www.digitalproduction.net)

Director and Founding Member of the UK Final Cut User Group, Apple Solutions Expert and freelance television director/editor, Rick has worked for the BBC, Sky, ITN, CNBC and Reuters. Also a Final Cut Pro Consultant and author of the best-selling *The Easy Guide to Final Cut Pro.*

Titles in the series:

***The Easy Guide to Final Cut Pro 3*, Rick Young**

***The Focal Easy Guide to Final Cut Pro 4*, Rick Young**

***The Focal Easy Guide to Final Cut Express*, Rick Young**

***The Focal Easy Guide to Maya 5*, Jason Patnode**

***The Focal Easy Guide to Discreet Combustion 3*, Gary M. Davis**

***The Focal Easy Guide to Premiere Pro*, Tim Kolb**

THE FOCAL EASY GUIDE TO

FLASH MX 2004

For new users and professionals

BIRGITTA HOSEA

AMSTERDAM • BOSTON • HEIDELBERG • LONDON • NEW YORK • OXFORD
PARIS • SAN DIEGO • SAN FRANCISCO • SINGAPORE • SYDNEY • TOKYO

Focal Press is an imprint of Elsevier

ELSEVIER

Focal Press
An imprint of Elsevier
Linacre House, Jordan Hill, Oxford OX2 8DP
200 Wheeler Road, Burlington MA 01803

First published 2004

British Library Cataloguing in Publication Data
A catalogue record for this book is available from the British Library

Library of Congress Cataloguing in Publication Data
A catalogue record for this book is available from the Library of Congress

ISBN 0 240 51959 0

For information on all Focal Press publications visit our website at:
www.focalpress.com

Typeset by Newgen Imaging Systems (P) Ltd., Chennai, India
Printed and bound in Italy

Working together to grow
libraries in developing countries

www.elsevier.com | www.bookaid.org | www.sabre.org

ELSEVIER BOOK AID International Sabre Foundation

Contents

CHAPTER 1
INTRODUCTION

History and Development of the Program

SmartSketch was a drawing application originally developed in the early 1990s by Jonathan Gay and his company Future Splash, which developed into an animation program for the Internet – Future Splash Animator. Future Splash was a small company with one of many multimedia plug-ins struggling for attention. It was offered for sale to Adobe who turned it down due to its unimpressive performance.

Although the early versions were slow and buggy, Disney started using it along with Shockwave and this attracted the attention of Macromedia. The Shockwave Flash plug-in format was then developed by Macromedia to play back small and fast vector animated content on the web. In December 1996 Flash 1 was born.

Flash is now in version 7. It has evolved into a sophisticated package for the creation of economical animation and interactive content. Due to its popularity, many other drawing and animation programs now have a Shockwave Flash export option.

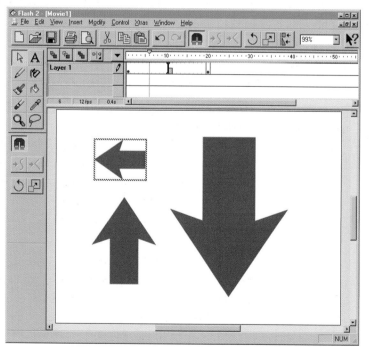

The New and Exciting Flash 2 from 1997

What is it Used for?

Flash is used for the creation of graphics, animation and media that users can interact with, such as interfaces, rich media web pages, games, real-time chat applications, interactive shopping systems, and video conferencing. Although the program is primarily associated with creating content for the Internet, Flash is also used to create standalone CD ROMS and presentations, animation for TV, content for PDAs, interactive television, kiosks and mobile phones.

How to Use This Book

The potential of this program is vast and it would be impossible to cover every single feature in one little Easy Guide. With the launch of Flash MX 2004, there are now two versions of the program – standard and professional. This book can be used with both versions.

The **Easy Guide to Flash** is designed to introduce you to the fundamentals of Flash – creating vector graphics, animation and basic interactivity, incorporating video and sound and exporting from the program to the Internet and to video.

When you have finished this book, if you are interested in learning more about ActionScripting or outputting to any of the more specialized delivery platforms there is a list of further resources in the appendix.

Each chapter covers one aspect of the program and contains step-by-step tutorials to enable you to start straight away. The book is extensively illustrated with screen shots from the program. Although the screen shot illustrations have been created on a Mac, the author is platform agnostic. The book has been checked on a PC and shortcuts for both platforms have been given.

The book uses certain conventions in order to avoid repetition and save space. In the case of choosing options from the various menus, the abbreviation **File > New** is used instead of saying go to the **File** menu then choose the **New** command from the drop down list of options.

File	Edit	Commands
New...		⌘N
Open...		⌘O
Open from Site...		
Open Recent		▶
Close		⌘W
Close All		
Save		⌘S
Save and Compact		
Save As...		⇧⌘S
Save as Template...		
Save All		
Import		▶
Page Setup...		
Print Margins...		
Print...		⌘P
Edit Sites...		

File > New

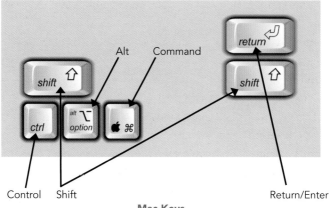

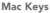

Mac Keys

PC Keys

Both Mac and PC shortcuts are given throughout. The shortcuts for Macs and PCs are similar, but frustratingly slightly different. Instead of writing them both out in full, the following conventions are used.

- For the **Command** key (Mac) **CMND** is used, followed by **CTRL** for the **Control** key, which is the PC equivalent. For example the keyboard shortcut for **File > New** is written as **CMND/CTRL + N**.

- **ALT** is used throughout as an abbreviation for the **Option** key (Mac) and **ALT** key (PC).
- PC users have a right mouse button, which can be used to open context sensitive menus when you apply it to different parts of the program. The Mac equivalent of a right mouse click is to hold down the **CTRL** key. This is abbreviated throughout as **CTRL/RIGHT-CLICK**.
- Another convention used throughout the book is that the final product of your Flash project is referred to as a '**movie**'. Of course your end product need not be animation. It could be a web site or even a CD-ROM, but to simplify matters it is referred to as a '**movie**'.

Finally, you will only ever really start to learn a piece of software when you apply it to your own projects. This book is designed to provide you with a fundamental vocabulary in Flash. The rest is up to you. Use the exercises here as a starting point, adapt and change them to suit your own designs and ideas and you will be fluent in Flash in no time! So open up Flash on your computer and let's start exploring the interface.

CHAPTER 2
INTERFACE

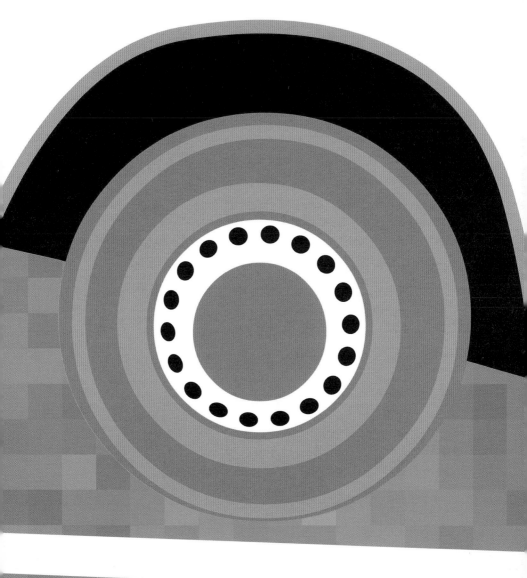

The MX series of programs have interface elements that are common to all Macromedia web and multimedia authoring products. So, once you are familiar with one of the Macromedia programs, you will be on your way to understanding the others.

Click Here if You don't Want to see this Page Again

Start Page

The Start Page

1 The Start Page is a new feature of Flash MX 2004 and one that is becoming common across many other programs too. It allows you to quickly access files and create new items. When you first begin to use

the program it is worthwhile spending some time taking the quick tour of Flash and taking some of the in-built Flash lessons, which you can access from this page.

2 If you don't want to see this page again, click in the check box to select **Don't show again**. If you want to make sure that this page will open each time you open Flash, you need to select this in the preferences. To do this on a Mac, go to **Flash > Preferences > On launch > Show Start Page**.

Preferences

| General | Editing | Clipboard | Warnings | ActionScript |

General

Undo levels: 100

Selection options: ☑ Shift select
☑ Show tooltips

Timeline options: ☐ Disable timeline docking
☐ Span based selection
☐ Named anchor on Scene

Highlight color: ⦿ Use this color ▪️
○ Use layer color

Font mapping default: _sans

On launch: ⦿ Show Start Page
○ New document
○ Last documents open
○ No document

Cancel OK

Show Start Page

3 To do this on a PC, go to **Edit > Preferences > Show Start Page**.

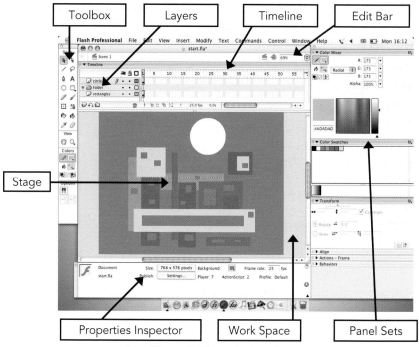

At a Glance Guide to the Interface

Menus – Just as in any other software program, access different parts of the software by choosing from the menus at the top of the screen.

Stage – This is where you create and view your design work.

Workspace – The gray area off the edge of the Stage that won't be seen in the final movie. It can be shown or hidden by choosing **View >
Work Area.**

Tools – To create, select, refine and manipulate design elements. See Chapters 3 and 4 for details about using these tools.

Timeline – A grid showing each frame of the Flash movie. It enables you to work with the element of time, moving horizontally from left to right. The numbers along the top refer to the number of frames in your movie.

Edit Bar – Shows which scene or symbol you are working on and allows you to change the view on the right. Can be turned on or off by selecting **Window > Toolbars > Edit Bar**.

Layers – Elements can be separated into layers to keep them distinct and are essential if you want to animate them. Layers are stacked vertically – one on top of each other like sheets of paper. See Chapter 4 for more information about layers.

Panel Sets – Additional windows allowing you to control and manipulate your design elements as well as adding interactivity. These are accessed through the **Windows** menu.

Properties Inspector – This is context sensitive and changes according to which part of the interface is selected. If it is not visible, select **Window > Properties**.

What are all the Windows for?

The Stage

1 The Stage is like your drawing board – it's where all the action happens. The size of the Stage defines the size of your final Flash movie. You can change the **size** of your movie by selecting **Modify > Document**. This launches the **Document Properties**.

Size Button

2 You can also open this window by first clicking on the background of your Stage to select it and then by clicking on the **size** button in the **Properties Inspector**.

Document Properties

| Dimensions: | 768 px | (width) | x | 576 px | (height) |

Match: (Printer) (Contents) (Default)

Background color: ■▾

Frame rate: 25 fps

Ruler units: [Pixels ▲▼]

(Make Default) (Cancel) (OK)

3 The Document Properties window controls the pixel dimensions of the Stage and, therefore, of the final movie. These dimensions are 550 × 400 pixels by default. The smallest size you can have is 1 × 1 pixels and the largest is 2880 × 2880 pixels.

4 Chapter 13 discusses several possible sizes for banner ads and whole web sites. It is good practice to set the size of your Stage right at the beginning of working on your document. If you resize the Stage towards the end of working on your document, you may have to re-position all your elements and this could be time consuming.

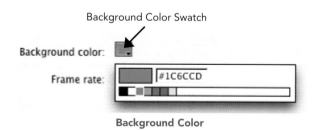

Background Color Swatch

Background color:

Frame rate: #1C6CCD

Background Color

5 The background color of your document can be changed by clicking, holding and then sliding the mouse down from the **background color swatch** to select whichever color you choose.

6 The ruler units can be changed to measure in inches, points, centimeters and millimeters as well as pixels. It is advisable to keep this as **pixels**

Background color:

Frame rate:

Ruler units:

Inches
Inches (decimal)
Points
Centimeters
Millimeters
✓ Pixels

Ruler Units

unless you are using Flash to create illustrations for print. Screen based work such as web sites and animation for video are measured in pixels.

7 If there is a size, background color and frame rate that you usually use – click on the **default** button so that you will automatically use these settings in future.

Make Default

The Timeline

The Timeline

1 The Timeline allows you to create and edit animations – to move forwards and backwards in time.

| 1 | 5 | 10 | 15 | 20 | 25 | 30 | 35 | 40 | 45 | 50 | 55 |

Measured in Frames

2 The units of measurement along the top of the ruler are in frames.

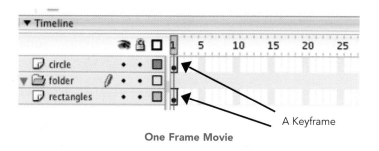

A Keyframe

One Frame Movie

3 The length of your movie is controlled by how many keyframes and frames you have created in the Timeline. In this example there is only one keyframe. This means that this movie doesn't have any time to move – it is actually a still image.

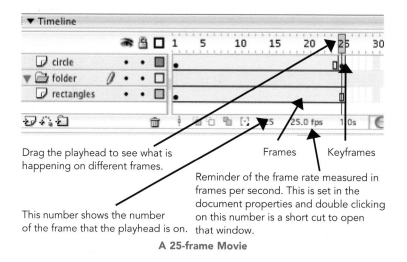

Drag the playhead to see what is happening on different frames.

Frames Keyframes

Reminder of the frame rate measured in frames per second. This is set in the document properties and double clicking on this number is a short cut to open that window.

This number shows the number of the frame that the playhead is on.

A 25-frame Movie

4 In this example there are 25 frames and the frame rate is set at 25 frames per second, so there is one second of animation. For more information about keyframes see Chapter 6. There is more about frame rate in Chapter 8.

Panel Sets and Customizing Your Interface

1 There are many extra small windows called **Panels**, which add extra functionality to Flash and can be opened through the **Window** menu. These will be covered in more detail in the chapter that covers their individual functions.

2 If all of the Panels were to open at once you would need a really large monitor to see them all! This is not necessary, however, because you can customize your interface to suit the way in which you are working.

3 The easiest way to customize your interface is to press **F4** to hide or open Tools, Panels, and Properties.

▶ Color Mixer

Color Mixer Panel Collapsed

▼ Color Mixer

Color Mixer Panel Expanded

4 The **Timeline** and the **Panels** can all be collapsed. This is done by clicking on the little triangle to the left of the window's name.

▼ Color Mixer

Panel Options Menu

5 You don't have to have the default Panels open that were there when you first installed Flash. You can choose which Panels you want to have open. To close a Panel, click on the options menu on the right-hand side of its title and choose **Close Panel**.

✓ RGB
HSB
Add Swatch
Help
Maximize Panel
Close Panel

Close Panel

6 The Panels are all dockable. This means you can group them with other Panels or change their position. If you move your mouse so that the cursor is over the **Panel handle**, the icon will turn into a hand. You can now drag a Panel out of a docked position.

Panel Handle

7 If you want to add a Panel to a group of Panels so that it will become docked, drag the Panel over the position that you want it to have in the Panel group. You will see a dark line overlapping the position this Panel will take.

Panel Overlap

Let go and the Panel will be in its new position.

8 To float the **Toolbar** if you are using a PC, click then drag on an empty area. This detaches it from the default position allowing you to change the work area. All Panels in the Windows version can be detached in a similar way including the **Timeline** and **Properties Inspector**.

Panel Focus

9 There are some clever keyboard shortcuts that you can use with Panels. If you select **CMND/CTRL + ALT + TAB** this puts a **'focus'** on the Timeline or uppermost Panel. You can then press this key combination again to cycle through all of the open Panels.

10 Once you have a Panel in 'focus', then the **Up** and **Down** arrow keys also cycle through the Panels and the **Space Bar** collapses/expands the Panel in 'focus'.

11 When you have selected the Panels you want to use and moved

> ### Save Panel Layout
>
> Name: my favorite|
>
> OK
>
> Cancel

them into your preferred position, you can save the Panel layout. In fact, you could save different layouts for working in different areas of the program, for example, drawing, animating, creating buttons, etc.

12 To do this, go to **Window > Save Panel Layout**, name your Panel arrangement and click **OK**. This arrangement will now be available for you in **Window > Panel Sets**.

13 The Panels that I find most useful from a Designer's perspective to save into a Panel set are the following: **color mixer, color swatches, transform, align, actions**, and **behaviors**.

Using the Help files

1 The **Help** files contain lots of detailed explanation about all areas of Flash. The Help menu allows you to jump to different parts of the Help files. In the **Help > How Do I ...** section, you can access lessons on all the basic features of the program.

2 **Help > Using Flash** takes you straight to sections of information covering all of the different areas.

Flash Documents

1 When you work in Flash, the type of file that you are working on is a **Flash document** or **FLA** file. If you want to change or do more work on your Flash document or to open it on another computer – **select File > Save** and save the FLA file. Give it a name related to the contents so that you can remember what it contained.

2 From this Flash document, you can export other files that can then be put onto a web page or burnt onto a DVD. This will be covered in more detail in Chapters 14 and 15.

Naming Files and Working Cross Platform

1 PC file names generally have a three-letter extension at the end. The extension for a FLA file is **.fla**, for example, **mydocument.fla**. What these three letters do is instruct the PC as to the type of file that it is referring to.

2 A Macintosh computer doesn't work in the same way and doesn't need the .fla filename extension to enable it to recognize the file type.

3 So, if you want to work cross-platform, you have to think about file naming conventions. If you create a Flash document on a Macintosh and have named it with a PC style three letter extension, for example, mydocument.fla, then it should open on a PC without a problem.

4 There are sometimes problems, however, the other way around. If you have created a Flash document on a PC and it won't open on a Macintosh, then you need to do a search on the internet and get hold of a little utility called **Flash Typer**. This will give your Mac the information it needs to recognize the Flash file format.

Saving as a Flash MX Document

5 Even though you may be working with the latest version of Flash – Flash MX 2004 – you may find yourself working with people who have the previous version of the program. If you save as a Flash MX 2004 file, you will only be able to open it on Flash MX 2004. However, you can choose **File** > **Save As** > **Format** > **Flash MX Document**. This file

can then be opened on Flash MX, although certain MX 2004 features such as behaviors will not be preserved.

6 Finally, don't forget to save your work regularly. Occasionally any program can crash while you are working and if you have saved recently this will only be a minor inconvenience.

What is vector drawing? It is a way to create and save digital imaging information. The edges are crisp, the colors are flat and the artwork you create is editable. In other words, you can go back to a graphic that you have created and easily modify its outline, color etc. Getting to know the drawing Tools and all the different mark making possibilities in the program is the first step towards developing your own original style in Flash.

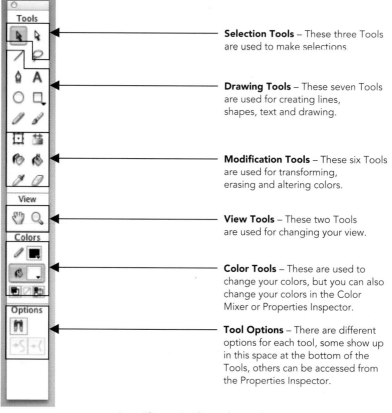

Selection Tools – These three Tools are used to make selections.

Drawing Tools – These seven Tools are used for creating lines, shapes, text and drawing.

Modification Tools – These six Tools are used for transforming, erasing and altering colors.

View Tools – These two Tools are used for changing your view.

Color Tools – These are used to change your colors, but you can also change your colors in the Color Mixer or Properties Inspector.

Tool Options – There are different options for each tool, some show up in this space at the bottom of the Tools, others can be accessed from the Properties Inspector.

At a Glance Guide to the Tools

The Drawing Tools

When you create a piece of artwork in Flash, it is known as a '**shape**'. The outline is called the '**stroke**' and the center is called the '**fill**'.

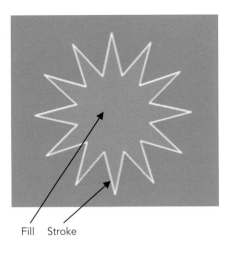

Fill Stroke **A Shape**

Colors

Click and hold
to change the
Fill color and
Stroke color

Fill and Stroke Colors

Drawing a Line

1 You can create many different types of lines in Flash.
After selecting the **Line** tool, you then choose the **stroke**
attributes in the **Toolbox, Properties Inspector** or in the **The Line Tool**
Color Mixer panel.

2 Click and drag the line on the Stage. Click a second time to end the
line.

3 Holding down shift while you are dragging a line, constrains it to
increments of 45°.

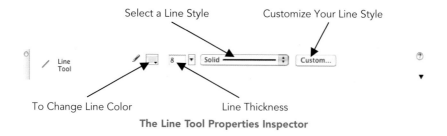

The Line Tool Properties Inspector

4 When the **Line** tool is being used, you are able to access options for your line in the **Properties Inspector** as shown in the diagram above. Clicking on the **Custom** button opens the **Stroke Style** window, which gives you lots of different options to create lines with different textures.

5 Explore and experiment with all the different line styles to create texture and diversity in your drawing.

6 NB. If you are creating animation that you later want to put onto video, avoid the hairline thickness option. When used on video one pixel thin lines can seem to jitter. More on this in Chapter 12.

Line Options

The Shape Tools

1 The **Oval, Rectangle** and PolyStar Tools are used in a similar way to the **Line** tool. The PolyStar tool is accessed by clicking and holding on the Rectangle tool.

Shape Tools

2 The stroke color and style can be selected and the stroke style customized in the Properties Inspector, just as with the **Line** tool. The fill color can also be chosen here.

3 Holding down **SHIFT** while you are drawing an oval or a rectangle constrains the proportions so that you end up with a perfect circle or square.

4 The **PolyStar** tool has an extra set of style options in the Properties Inspector. These are reached by clicking on **Options** and allow you to choose polygon or star, the number of sides and the depth of points.

Tool Settings

Style	star
Number of Sides	12
Star point size	0.50

Cancel OK

PolyStar Tool Settings

5 The **Rectangle** tool has options available at the bottom of the Toolbox. If **Snap to Objects** is selected, you will feel a slight magnetic pull when your rectangle is near other shapes.

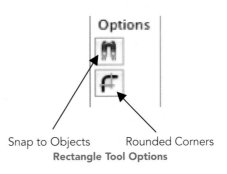

Options

Snap to Objects Rounded Corners
Rectangle Tool Options

6 When you select the rounded corner option, the Rectangle

Rectangle Settings

Corner radius: 15 points [OK]

[Cancel]

Settings window opens. This prompts you to add a figure, which defines how curved the corner will be.

7 If you prefer to set the roundness of your corners visually, use the **Up** and **Down** arrow keys while you are drawing your rectangle – don't take your finger off your mouse.

Drawing with the Pencil tool

1 The **Pencil** tool is another way to create lines, that is, **strokes**. So, as with the **Line** tool, when the **Pencil** tool is selected, you can choose a color from the stroke color control in the Toolbox or the Color Mixer panel.

The Pencil Tool

2 In addition, the stroke color and style can be selected and the stroke style customized in the Properties Inspector.

3 In the **Options** section at the bottom of the **Toolbox**, you can choose a **drawing mode**. The drawing modifiers selected effect how Flash processes the lines you draw. **Straighten** will straighten out your lines and recognize simple shapes, **Smooth** will give more smooth curves and **Ink** allows you to draw free hand, leaving the line exactly as you drew it without modification.

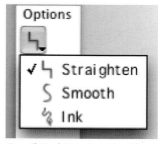

Pencil Tool Drawing Modifiers

Painting with the Brush tool

1 You can change the color of the **Brush** tool in
the **Toolbox, Properties Inspector** or the **Color
Mixer** panel, however unlike the **Line** and the
Pencil Tools the color of this tool is changed in the **fill**
color control.

The Brush Tool

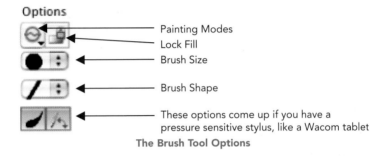

Options

— Painting Modes
— Lock Fill
— Brush Size

— Brush Shape

— These options come up if you have a
pressure sensitive stylus, like a Wacom tablet

The Brush Tool Options

2 From these Options, you can choose your brush size and shape. As the
Brush tool is painting with fills and not a stroke, you can't change the
line style.

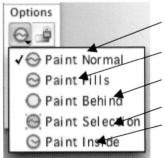

Paint Normal – Paints over lines and fills
on the same layer.

Paint Fills – Paints fills and empty areas,
leaving lines unaffected.

Paint Behind – paints in blank areas of the Stage,
leaving lines and fills unaffected.

Paint Selection – paints the selected fill.

Paint Inside – paints the fill in which you start
a brush stroke and never paints lines.
Its just like a coloring book!

The Painting Modes

Go Mad with the Brush Tool – You Know You Want to!

Using the Pen tool and the Subselection tool

1 The **Pen** tool is used to create anchor points with connecting lines – just like a game of 'join the dots'! First select your required **fill** and **stroke** colors and then click to make angular, corner points – each click of the mouse creates another anchor point.

The Pen Tool

2 Clicking and dragging makes a curved, bezier point. Double clicking ends the shape. When the path that the anchor points make is joined up, the shape will fill with color.

3 Drag on the handles to alter the curvature of the line. Holding down the **ALT** key when you drag on a handle allows you to move it independently from its partner.

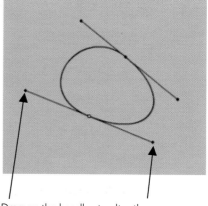

Drag on the handles to alter the curve

Bezier Curves with the Pen Tool

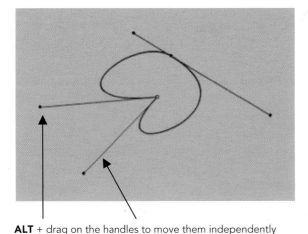

ALT + drag on the handles to move them independently

Bezier Curves with the Pen Tool

4 As you move the **Pen** tool, the cursor changes if you are near a point or the line created. You can delete, modify or add points according to where the **Pen** tool is.

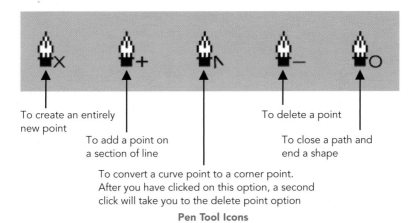

To create an entirely new point

To add a point on a section of line

To convert a curve point to a corner point. After you have clicked on this option, a second click will take you to the delete point option

To delete a point

To close a path and end a shape

Pen Tool Icons

5 Using the **Subselection** tool allows you to convert a shape you have drawn with any of the drawing Tools into anchor points. These points

The Subselection Tool

can then be carefully selected and moved individually – using the arrow keys nudges these points one pixel at a time. You can also delete them with the **delete** key on your keyboard.

6 The **Pen** tool can be used to add, delete or convert anchor points on shapes that you have drawn with other Tools.

7 A corner point can also be turned into a curved path by selecting the point with the **Subselection** tool, holding down the **ALT** key and dragging out a curve. If you want to try the opposite and turn a curved point into a corner point, hold down the **ALT** key and double-click to convert it.

An Anchor Point is Darker when it is Selected

Changing Colors

1 We have already seen how colors can be selected in the **Toolbox** and the **Properties Inspector**. If you want to create a shape without an outline, select the **Stroke Color Control** and then choose **no color**.

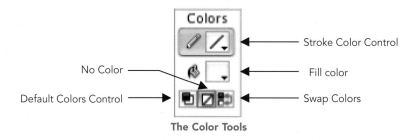

The Color Tools

2 The **Color Swatches** panel is another convenient way to select colors. If you can't see this panel, choose **Window** > **Design Panels** > **Color Swatches** to open it.

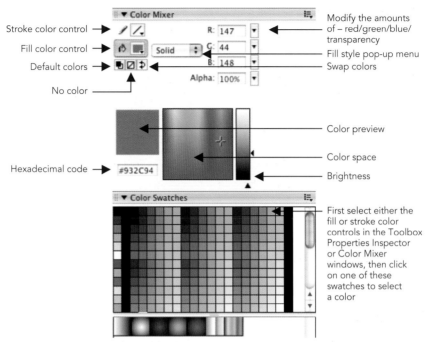

The Color Mixer and Color Swatches Panels

3 There are several ways to create new colors in the **Color Mixer** panel. If you can't see this panel, choose **Window > Design Panels > Color Mixer** to open it.

4 If you are creating a web site and know the precise color that you want to use, you can type in the **hexadecimal code**.

5 You can also move the **red, green, blue** and **alpha** (transparency) **sliders** to subtly change a color's component parts.

6 Finally, you can also click around in the **color space** to define a color and then drag the **brightness** slider to alter its tonality.

Creating Gradient Fills

1 Choose **Linear** or **Radial** from the **Fill Type** pop-up menu in **Color Mixer** panel.

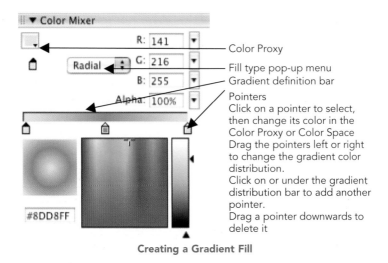

Creating a Gradient Fill

- Color Proxy
- Fill type pop-up menu
- Gradient definition bar
- Pointers
 Click on a pointer to select, then change its color in the Color Proxy or Color Space
 Drag the pointers left or right to change the gradient color distribution.
 Click on or under the gradient distribution bar to add another pointer.
 Drag a pointer downwards to delete it

2 When you have created a gradient fill, you can save it for re-use. Click on the **Color Mixer** Options menu and choose **Add Swatch**.

3 Your gradient fill is now available for you at the bottom of the **Color Swatches**.

✓ RGB
HSB

Add Swatch

Help
Maximize Panel
Close Panel

Add Swatch

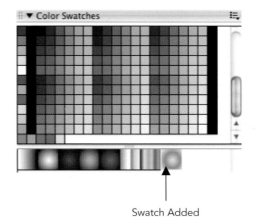

Swatch Added

Transform Fill Tool

4 Your gradient fill can be altered, re-sized and re-angled after you have created it with the **Transform Fill** tool. Select this tool in the Toolbox and then click on the shape whose gradient you want to alter.

Transform Fill Tool

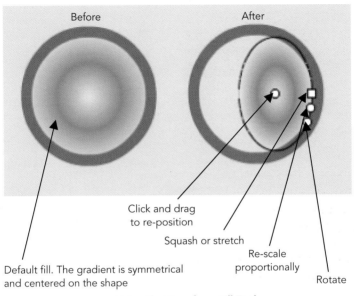

Before

After

Click and drag
to re-position

Squash or stretch

Re-scale
proportionally

Rotate

Default fill. The gradient is symmetrical
and centered on the shape

Using the Transform Fill Tool

5 If you want your **gradient fill** to extend across several shapes on the Stage, select the **Lock Fill** modifier from the **Brush** or **Paint Bucket** tool.

Shapes with Lock Fill Applied

Creating Text

1 Text is created in Flash with the **Text** tool and the style of the text is changed in the **Properties Inspector**.

A

The Text Tool

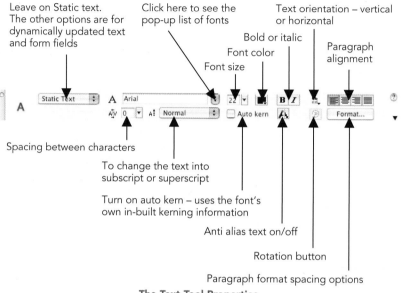

Leave on Static text. The other options are for dynamically updated text and form fields

Click here to see the pop-up list of fonts

Text orientation – vertical or horizontal

Bold or italic

Font color

Paragraph alignment

Font size

Spacing between characters

To change the text into subscript or superscript

Turn on auto kern – uses the font's own in-built kerning information

Anti alias text on/off

Rotation button

Paragraph format spacing options

The Text Tool Properties

2 After you have selected the **Text** tool, you can either click on the Stage to type letters all in a line or you can click and drag out a type box. This will allow you to type continuously into a box with a fixed width.

An Empty Type Box

3 As well as typing into Flash, when you use the Text tool you can copy and paste text information from another text program on your computer.

bbbbbbbbbbbb
bbbbbbbbbbbb
bbbbbbbbbbbb
bbbbbbb|

Typing with a Fixed Width

4 Text in Flash is editable, this means that when your text is selected you can alter properties like font, size and color as well as re-typing the letters.

Selected Text

5 When on the **Text** tool, you can click and drag over the text to highlight part of it. This will allow you to use different styles on different parts of your text.

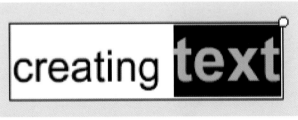

Different Text Styles

6 When your text is highlighted and you click on the pop-up menu to change the font, you will see a preview of your chosen text in all the different fonts as you scroll up and down them.

7 Not all fonts can be embedded in your Flash project. If a font is not embedded and the user doesn't have it on their machine a substitute will replace the font you used and your page design might not look at all as you intended.

8 One way to make sure the font will look predictable is to transform the text information into a vector graphic shape. Only do this if you are completely happy with your text style and spelling!

9 To convert your editable text into a shape, select the text, then **Modify >** **Break Apart**. This breaks the text into individual letters. Apply **Modify > Break Apart** a second time and the letters will be understood by Flash as a graphic shape and not as editable text.

**Text that has been Broken Apart
into Individual Letters**

**Text that has been Broken Apart
Again into Graphic Shapes**

10 The result is that these letters will now look the same on any computer
– no matter which fonts the system has loaded. The down side is that
this process can add to the file size and may be frustrating if you want
to go back and alter the wording of the text.

Spell Checker

1 Go to **Text** > **Check Spelling** to check the spelling in your document.
You have the choice to **ignore** the spelling advice given or **change**.

2 If you commonly use certain words that the program considers you are
spelling 'wrong', then select **Add to Personal** to remember this in
future.

3 **Text** > **Spelling Set Up** allows you to personalize the spelling options.

CHAPTER 4
SELECTING AND MODIFYING

As we have seen in the previous chapter, the beauty of vector drawing is that it is so easily adaptable. Basic artwork is known as shape data and can be edited, molded and manipulated.

Making Selections

1 If you have created a shape with a **fill** and a **stroke**, clicking it once with the **Selection** tool will only select the **fill**. To select all drawn elements connected to one shape, double click with the **Selection** tool.

The Selection Tool

2 To select several shapes within a rectangular marquee area, click and drag a box around all the shapes with the **Selection** tool. Symbols, groups, and text objects must be completely enclosed to be selected.

3 You can also duplicate with the **Selection** tool. **SHIFT + drag** selection makes a copy.

4 To create an area of selection by drawing, use the **Lasso** tool. When the cursor is over a selected element, the **Lasso** tool becomes an arrow that you can use to move the element.

The Lasso Tool

5 To make multiple marquee or **Lasso** tool selections, press **SHIFT** while you lasso or marquee-select.

6 To select everything on every layer of the scene, choose **Edit > Select All**, or press **CMND/CTRL + A**.

7 To deselect everything on every layer, choose **Edit > Deselect All**, or press **CMND/CTRL + SHIFT + A**.

Modifying Drawings

1 The **Selection** tool can also be used to modify drawings. When you have this tool selected in the toolbox and move your cursor around a shape you have created that is not selected, the icon will change according to whether it is over a line, a corner or away from a shape.

2 If you are over a line and see the first icon, you can drag on the line and pull out a curve.

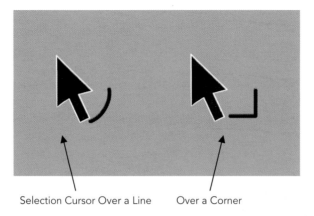

Selection Cursor Over a Line Over a Corner

3 If you are over a corner and see the second icon, you can pull out the corner.

4 If you are over a line and hold down the **ALT** key, you can pull a corner point out of a line.

5 This is a good method to quickly sculpt shapes into the form you require. In the last chapter, we saw how the **Subselection** tool used in conjunction with the **Pen** tool gives very precise control over your drawing. Sometimes, however, it is better to work quicker and rougher and create your basic shape before refining it further, rather than being very careful and drawing a complex shape from the beginning.

6 If you select a shape with the **Selection** tool and then click on the **Straighten** option – the outline of the shape will become straighter and

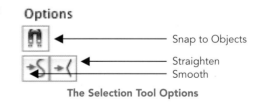

more angular. Clicking on the **Smoothing** option will make your shape have smoother curves.

7 Turning on **Snap to Objects** will give you a slight magnetic pull when one shape is near another.

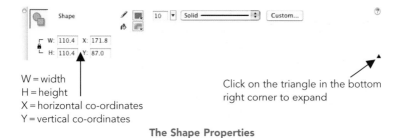

W = width
H = height
X = horizontal co-ordinates
Y = vertical co-ordinates

Click on the triangle in the bottom right corner to expand

The Shape Properties

8 When you have selected a shape with the **Selection** tool, you can see the properties of the **Shape** in the **Properties Inspector**. Expanding this window allows you to see the W, H, X, and Y figures. By entering X and Y co-ordinates in Properties Inspector, the shape can be moved in exact amounts.

The Free Transform Tool

1 When you select this tool, you can rotate the selection by moving the cursor just outside the corner handles or move the selection by dragging from a central position. The white dot is the center point. Dragging this to a new position will change your center of transformation. It will not change the position of your shape. Drag out the corners to re-scale.

The Free Transform Tool

Options

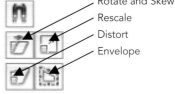

Rotate and Skew
Rescale
Distort
Envelope

The Free Transform Tool Options

2 When you have the freedom to use all of the options at once, it can be easy to drag in the wrong place and end up with an unexpected result. Selecting one of the **Free Transform** options limits the transformation to the one you have selected.

3 If you think that you have gone too far with your transformations and want to return to your original version, don't worry, just choose **Modify > Transform > Remove Transformation** or more simply **CMND/CTRL + SHIFT + Z.**

Rotate and Skew. SHIFT + drag to rotate in 45° increments.

Rescale. Drag on the corner handles to rescale proportionally. Drag on the central handles to squash and stretch.

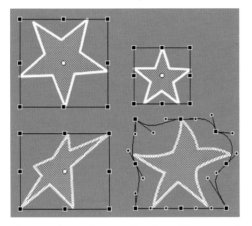

Distort. Drag an edge to distort the shape. SHIFT + drag on a corner point to taper the shape. CMND/CTRL + drag on the central point of an edge allows you to move it freely.

Envelope. Allows you to 'warp' a shape by dragging on the points and their handles.

The Free Transform Options Demonstrated

4 As well as altering shapes with the **Free Transform** tool, transformations can be applied numerically in the **Transform** panel. If this panel is not already open, select **Window > Design Panels > Transform** or more simply **CMND/CTRL + T**.

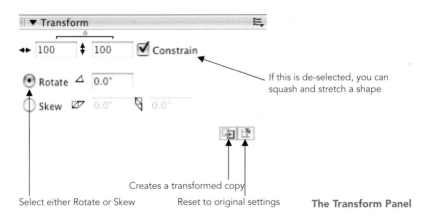

If this is de-selected, you can squash and stretch a shape

Creates a transformed copy

Select either Rotate or Skew

Reset to original settings

The Transform Panel

There are a series of other tools that allow you to modify your drawings in Flash:

Ink Bottle Tool �➡ Paint Bucket Tool

Eyedropper Tool ➡ Eraser Tool

Ink Bottle Tool

This handy little tool allows you to change the thickness, color or style of existing lines (i.e. strokes). You first set up a new line style in the **Properties Inspector** then click on the line you want to change with the **Ink Bottle** tool.

Paint Bucket Tool

1 This tool is used to change the color of existing fills, anything created with the **Brush** tool and to fill areas surrounded by lines. Select the color you want to use in the **Fill Color Control** first, then use the **Paint Bucket** tool to click into the area you want to color.

2 Occasionally you may find that this tool just doesn't work. The most common reason for this is that the shape you are trying to color has very small gaps in its outline.

3 Luckily, this tool has a built-in **gap size modifier** in case there are gaps in your shape. Select **Close Large Gaps** from these options at the bottom of the **Toolbox** and this should deal with the problem.

The Paint Bucket Options

4 A common mistake that people make with the **Paint Bucket** tool is to try to use it to color in the background of their image. Remember that

the background color is selected in the **Document Properties** and can't be applied with the **Paint Bucket** tool.

Dropper Tool

1 This tool is useful for copying **stroke** and **fill** attributes from other elements. It selects either depending on whether you use it to select a fill or a stroke. You can then take this information and apply it to other fills with the **Paint Bucket** tool or other strokes with the **Ink Bottle** tool.

2 **SHIFT** + click with the **Eyedropper** selects the current color for both the stroke **and** the fill.

Eraser Tool

The **Eraser** tool has a number of options at the bottom of the **Toolbox**. You can choose the shape of the eraser and eraser modes, which are similar to the **Brush** tool modifiers.

Selecting the faucet allows you to click and erase large areas

These are similar to the Brush tool

The Eraser Tool Options

Changing Your View

1 The **Zoom** tool allows you to magnify your view. **CMND/CTRL** + − or + also allows you to do this. Double-clicking on the **Zoom** tool icon in the **Toolbox** resets your view to 100%.

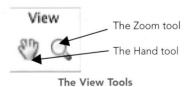

The Zoom tool

The Hand tool

The View Tools

2 Pressing and holding down the spacebar allows you to toggle to the **Hand** tool even though you are on the **Zoom** tool.

3 The **Hand** tool allows you to move around the area that you are viewing. Double-clicking on the **Hand** tool centers your frame within the work area.

4 The scale of your view can also be chosen in the **Stage magnification** options in the **Edit Bar** at the top of your **Timeline**. If you can't see it choose

Window > Toolbars > Edit Bar.

78%	Fit in Window
	Show Frame
	Show All
45 50 55	25%
	50%
	100%
	200%
	400%
	800%

The Stage Magnification Options in the Edit Bar

Using Layers

1 After you have been experimenting with the drawing tools for a while, you may notice something that happens when you overlap shapes. If you overlap one shape with another of the same color, after it is de-selected it will become joined to the first shape.

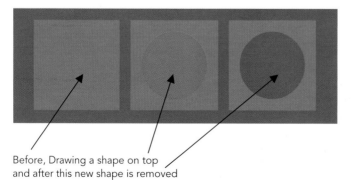

Before, Drawing a shape on top
and after this new shape is removed

Cutting a Hole

2 If the second shape is not the same color as the first, it will cut a hole in the first shape underneath. You can use this deliberately to create holes in objects, but you may wish to avoid this happening altogether. This can be done by putting different elements of your image on different layers.

The pencil icon shows you that this layer is the active one that you are working on. Drag layers up and down to change their order. The highest layer is in the front in the foreground, so put backgrounds on the lowest layer

Click here to show or hide a layer

Double-click on the name of a layer to re-name it

Click here to lock a layer

A layer is indented underneath its guide layer

Click here to view a layer in outline

Drag layers up and down to change their order, the highest layer is in the front in the foreground so put backgrounds on the lowest layer

Click here to hide/ show all layers

Click here to lock/ unlock all layers

Click here to view all layers in outline/ normal mode

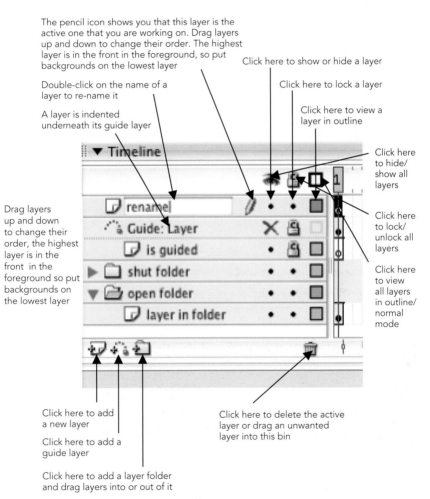

Click here to add a new layer

Click here to add a guide layer

Click here to add a layer folder and drag layers into or out of it

Click here to delete the active layer or drag an unwanted layer into this bin

Layers

3 By default there is one layer in your **Timeline**. However, you need to put graphic elements that you want to keep separate on individual layers so they do not merge with the shape is underneath.

4 To create a new layer: **Insert** > **Timeline** > **Layer** or more simply click on the **add layer** icon.

5 Each layer has its own color. This is seen when viewing an anchor point path or when seeing the layer in outline view. You can change this **outline color** so that it contrasts more effectively with the background that you are using. To do this, first select the layer, then **Modify** > **Timeline** > **Layer Properties** or more simply **CTRL/RIGHT-click** on the layer and select **Layer Properties**. The **outline color** can be changed in the window that opens.

6 Any item, however small, that is going to be animated needs to be on a separate layer, otherwise Flash won't be able to animate it properly.

7 If you click on a layer's name, you will automatically select all the elements on that layer.

Step by Step Manually Create a Drop Shadow

Later in the book we'll look at using **Timeline Effects** to automatically create drop shadows. However, creating them manually gives you a lot more control and creativity over the whole process.

1 Select the whole object that you want to create a shadow for.

2 Duplicate it – **CMND/CTRL + D** or **ALT + drag** selection makes a copy with the **Selection** tool.

3 Cut (**CMND/CTRL + X**) and paste (**CMND/CTRL + V**) and put your shadow on a layer below.

4 While the shape is still selected, change the fill to a dark color and change alpha transparency in the **Color Mixer** panel to a low figure – in this example I used 30%.

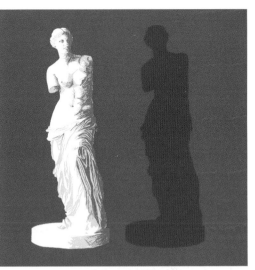

Creating a Drop Shadow

5 Modify > Shape > Soften Fill Edges (but beware as this can take time to process and add to the file size in the case of complex shapes). In the example I used a **Distance** of 5 pixels and **Number of steps** – 5. Select your shadow and its new softened edge and Modify > Group to keep all the elements together.

Positioning the Drop Shadow

6 Examine where the light in your picture is coming from, offset by a few pixels and use the **Rotate** and **Skew** options in the **Free Transform** tool to position your shadow correctly.

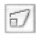

Rotate and Skew Options

Rulers, Guides and Grids

1 **Rulers, Grids** and **Guides** are useful utilities to aid your drawing process.

2 In order to create **Guides**, first select **View > Rulers**. You can then click on your left hand ruler and drag out a vertical guide or drag down a horizontal guide from the top ruler. If you can't see a guide, make sure **View > Guides > Show Guides** is selected.

3 If you want to permanently remove your guides, choose **View > Guides > Clear Guides**.

4 Similarly, choose **View > Grid > Show Grid** to view a grid and **Edit Grid** to change the size of the squares.

5 Grids and guides won't show up in your final movie.

6 Snapping means that there will be a small 'magnetic' pull between what you are drawing or moving and other elements. For example, **View > Snapping > Snap to Grid** means that when you draw near the intersections of the grid a small circle will appear and your shape will snap to that point.

7 **View > Snapping > Edit Snap Align** allows you to alter the snap tolerance. In other words, how close the edge of the object should be to another before it snaps into place.

8 **View > Snapping > Snap Align** – when this is selected, dotted lines appear on the stage when you drag an object to within the specified tolerance. If you drag your shape around the stage, you will see center, top, bottom, left, right alignment lines, depending on where the shape is dragged.

9 At times **snapping** can be a hindrance and prevent you from drawing exactly where you want to on the stage. If this is this case turn it off by deselecting the various snapping options in the **View** menu.

Step by Step to Create a Perspective Grid

1 Turn on **View > Show Grid** and **View > Snapping > Snap to Grid** and **View > Snapping > Snap to Object**.

2 Create a **guide layer**, by clicking on the **Add guide layer** button. Putting your grid on a guide layer means that you won't see it in your final movie.

3 Use the **Line** tool, the **grid** and **snapping** as a reference to build up a perspective grid on this guide layer.

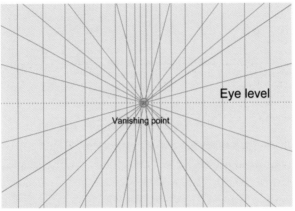

One Point Perspective Grid. Use this as Reference When You Want to Draw a Scene in Perspective with One Vanishing Point

4 Having snapping turned on will enable you to place the origins of your radiating lines exactly on the vanishing point.

5 You can convert a layer into a **guide layer** by **CTRL/ RIGHT-clicking** on a layer and then selecting **Guide**.

Converting to a Guide Layer

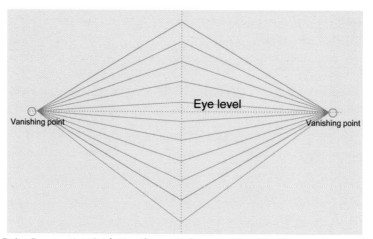

Two Point Perspective Grid. Use this as Reference When You Want to Draw a Scene in Perspective with Two Vanishing Points

6 When you have drawn your perspective grid, lock this guide layer so that you do not draw on it accidentally. Select **View Layer as Outlines**, so that it does not become too distracting.

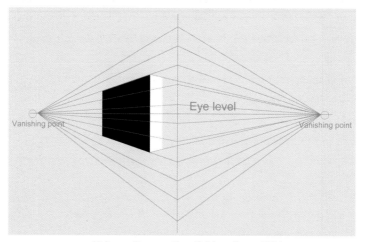

Using a Perspective Grid to Draw With

7 You can now use the **Free Transform Tool** to make your drawing work in your chosen perspective view.

8 All that hard work you put into creating a perspective grid can be used again. Select all of your perspective grid and then **Modify > Convert to Symbol**. Choose **Graphic** as the symbol type and give it a name that you will remember. You will now be able to re-cycle this grid many times.

Save as Template	
Name: Two Point Perspective	Preview:
Category: Perspective	
Description: Perspective grid	
	Cancel Save

9 Another way to re-cycle your perspective grid is to create a **Template**. Save your Flash document as a template with the perspective grid on a guide layer. Choose **File > Save As Template**. Give it a name, a description and either choose from the list of categories or create your own.

New from Template		
General Templates		
Category:	Templates:	Preview:
Advertising	Two Point Perspect...	
Form Applications		
guide logo		
Mobile Devices		
Perspective		
Photo Slideshows		
Presentations		
Quiz		
Slide Presentations		Description:
Video		Perspective grid

Creating a New File From a Template

10 Once you have created a template, you can use it as the basis for a new file. After you have selected **File > New**, you are able to choose the **Template** tab and the template you have created will be there available for you to choose.

At a Glance Keyboard Shortcuts for the Tools

Keyboard shortcuts are very useful to learn. Not only do they save you time and increase your productivity, but by varying the fingers you are using instead of just holding the mouse, they can help to reduce the chance of repetitive strain injury. Just hit the letter below on your keyboard and you will instantly select the tool.

Arrow tool	V		Sub-selection tool	A
Line tool	N		Lasso tool	L
Pen tool	P		Text tool	T
Oval tool	O		Rectangle tool	R
Pencil tool	Y		Brush tool	B
Free Transform	Q		Fill Transform tool	F
Ink tool	S		Bucket tool	K
Eyedropper tool	I		Eraser tool	E
Hand tool	H		Magnifier tool	M/Z

CHAPTER 5
IMPORTING IMAGES

Vectors vs. Bitmaps

Computers store picture information in two different ways – using **vector** or **bitmap file formats**.

A Vector at Maximum Magnification

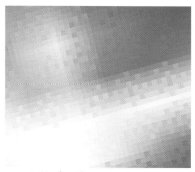

A Similar Shape at Maximum Magnification in Bitmap Format

When a **bitmap** file type is used, the computer divides the picture into a grid. You can see the squares on the grid if you zoom in very close to a bitmap image. These squares are known as **pixels**.

Bitmaps are good file types to use when you are working with very complex textures or photographs. However, the file sizes can be large and if your image is scanned or created with a low resolution to keep the file size down, you may get a **pixilated** image in which you can see the square outlines of your pixels.

Vector images, on the other hand, have very small file sizes. The computer uses geometry and mathematics to store the picture information.

Vector files are **resolution independent**. If you zoom in close to them, the outlines will remain crisp and perfect. They are good to use for graphics with blocks of color and gradients, but not so useful for complex textures.

Work produced in vector programs like Flash tend to have a particular 'look' about them. Get some texture into those clean looking vectors with the careful use of bitmaps.

Still Image File Types You can Import

Although Flash is a fantastic program to use for drawing, you may wish to bring in photographs or other types of images that you have created in software outside Flash. There are many options available to you.

There now follows a list of the main still image file formats that you can import into Flash and some information about them. Check out the Flash **Help** menu if you are interested in importing more specialized file types.

(i) *Bitmap File Formats*

Name	Details	PC file extension
Bitmap	Although this term denotes a type of file format (e.g. bitmap as opposed to vector), there is also a file format called bitmap or **BMP**. Although it is a standard PC file imaging file format, it can be imported to a Mac using QuickTime.	**.bmp**
EPS	**Encapsulated PostScript** language file format is supported by virtually all graphic, illustration, and page-layout programs. It is the most common format for use in desktop publishing. Any version can be imported.	**.eps**
GIF and animated gif	**Graphics Interchange Format** – commonly used on the web. It produces very small files by reducing the number of colors in your image to a maximum of 256. Consequently, this format is best used for graphics or cartoony type images with areas of flat color. Transparency can be attributed to colors.	**.gif**
JPEG	**Joint Photographic Experts Group** is commonly used for photographic images. It is a good format for reducing file size while keeping the quality high and commonly used on the web. This format is recommended to bring photographs into Flash, but cannot contain alpha channels.	**.jpg**
Photoshop	The default file format for newly created images in **Photoshop**, which can be imported into Flash if the computer has QuickTime 4 or above loaded. This file format supports all available image modes, guides, alpha channels, spot channels, and layers.	**.psd**

PDF	Version 1.4 or above can be imported.	**.pdf**
PICT	A Mac graphical image file format, which can be imported into Flash on a PC if the computer has QuickTime 4 or above loaded.	**.pct**
PNG	**Portable Network Graphics**, a more recent file format used on the web. Can compress to small file sizes while maintaining high quality of image. It supports multiple color depth and grayscales and can contain alpha channel transparency.	**.png**
	PNG is also the standard file format for newly created images in **Fireworks**. See below for more information.	
TGA	**Targa** files can support alpha channel transparency and can be imported into Flash if the computer has QuickTime 4 or above loaded. They are a good choice for exporting in a sequence for output to video.	**.tga**
TIFF	The **Tagged-Image File Format** is usually used for print as it can contain high-resolution data, be in RGB or CMYK or grayscale and can support alpha channel transparency. It can be imported into Flash if the computer has QuickTime 4 or above loaded.	**.tif**

(ii) Vector File Formats

Name	Details	PC file extension
Adobe Illustrator files	These files are the standard file format for newly created images in **Illustrator** and can contain layers and guides. Flash can import files from Illustrator version 6 or later. On import, you can choose to **flatten** all the layers or **convert the layers** into **layers** or **keyframes** in Flash.	**.ai**
Flash Player	The default file format that is exported from **Flash** to use on the web. You can also import these files into Flash.	**.swf**

Freehand	Files from **Freehand** version 7 up until 11 can be imported into Flash. Flash supports any layers you may have used in these files. If your Freehand file is in CMYK, Flash will convert it to RGB.	**.fh7**, **.fh8**, **.fh9**, **.fh10**, **.fh11**
	As with Illustrator, you can choose to **flatten** all the layers or **convert the layers** into **layers** or **keyframes** in Flash.	
PNG	This file format is also the generic format used by **Fireworks**. If you choose to import a **Fireworks PNG** as a **flattened image**, it will be **rasterized** or converted into a single bitmap image. If you import as an **editable object**, you will maintain the vector artwork.	**.png**

To Import a Still Image into Flash

1 Make sure the layer you want the image to be on is active.

2 Select **File** > **Import to Stage**.

3 You can also import numbered sequences of still images. If you do this, the stills will be brought in as successive frames of the layer that is active.

4 Your image file can be accessed in the **Library**. If you go to the **Library Options** menu and choose **Edit**, this command launches **Fireworks** or another image editing software package if you don't have Fireworks on your machine. There is more about libraries in the next chapter.

Importing Images with Areas of Transparency

If you define an area of transparency using your image editing software, you maintain this when you import the file into Flash. Here's how to do this using **Photoshop**:

1 In Photoshop, open up the file that you want to create transparency in.

2 Go to **Image** > **Image Size** and make a note of the pixel dimensions.

Image Size

Pixel Dimensions: 1.13M

Width: | 768 | pixels

Height: | 512 | pixels

Image Size Dialogue Box

3 Choose **File** > **New** to start a new file and make sure you have selected **Background** > **Transparent** and **Mode** > **RGB**.

4 The **Resolution** will always be 72 pixels/inch for **screen based** work like that for output to video or the Internet, as this is the resolution of the screen itself.

New

Name: | image will have transparent background | OK

Image Size: 1.13M

Preset Sizes: | Custom | Cancel

Width: | 768 | | pixels |

Height: | 512 | | pixels |

Resolution: | 72 | | pixels/inch |

Mode: | RGB Color |

Contents
○ White
○ Background Color
● Transparent

File > New

5 Make this new file exactly the same size as the image that you first imported.

6 Using the **Move** tool (shortcut – **V**), drag and drop the image onto the new blank file you created. If you hold down the **SHIFT** key while you drag and drop, the image will be placed in the center of the new file.

7 Close the original file.

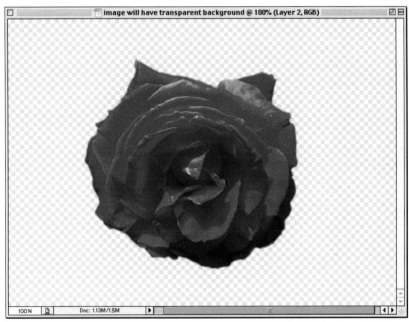

Delete the Unwanted Parts of the Image

8 Using any combination of selection tools, select the area you want to be transparent and then delete it.

9 File > **Save** and choose **PNG** as your file format, then **Interlace** > **None**.

The Image Without its Background in Flash

10 **Import** into Flash as above and your image should have a hole in it!

Tracing Bitmaps

If you want to reduce the file size of a bitmap image that you have brought into Flash, you can convert it into a vector graphic.

Another reason for doing this would be to change a photograph into a more stylized vector image.

1 Import the bitmap image file that you want to convert in Flash.

2 Make sure it's selected and then choose **Modify** > **Bitmap** > **Trace Bitmap**.

3 The options that are available are as follows:

- **Color threshold** = sensitivity of color selection
- **Minimum area** = the number of surrounding pixels to consider as one block
- **Curve fit** = how smoothly the outlines will be drawn
- **Corner fit** = how sharply the edges will be retained.

4 The following settings will give you the best possible settings, however this might take some time to process depending on the capabilities of your computer.

Trace Bitmap		
Color threshold: 10		OK
Minimum area: 1	pixels	Cancel
Curve fit: Pixels		
Corner threshold: Many corners		

The Best Quality Trace Bitmap Settings

5 Experiment with different settings until you achieve the style that you want. Lower quality settings will take much less time to process.

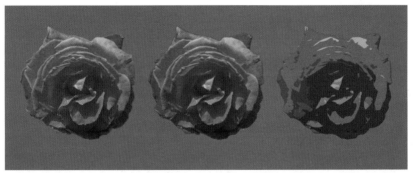

An Original Image and two Traced versions with different settings. The middle version has best quality settings applied as above. The one on the right Color Threshold = 100, Minimum Area = 10, Curve Fit = Smooth, Corner Fit = Normal

6 When you have first completed this process, all the bits of traced bitmap will be selected and it will appear to be grayed out.

7 Click away from the image onto a blank part of the Stage to deselect it.

8 You will now be able to adjust individual parts of the image just as if you had created the image in Flash with the **Paint** tool.

Painting with Bitmaps

It is possible to import textures and paint with them in Flash. This can be especially effective when used with small tileable textures like snakeskin or bricks.

1 Import the bitmap you want to use, make sure it is selected and **Modify > Break apart**.

2 Select the **Eyedropper** Tool and click on the broken apart bitmap.

An Imported PNG File

Painting with the PNG Snowflake

3 This loads the image into memory and you can now paint with it using the **Paint** tool. It will also **fill** any shape that you create with the **Pen** tool or the **Oval** or **Rectangle** tools.

4 The **Fill Transform** tool can be used to alter the scale, rotation and skew of the tiled image.

5 Finally, you can also select **Bitmap** as a **Fill** option in the **Color Mixer** panel. The bitmap will be tiled to fit the image and you can adjust it as above.

Finally, copyright issues don't just apply to music, but also to images. It may be tempting to use other people's images that you have found in books, magazines or on the web, but this is someone else's intellectual property. Ultimately, it is much more rewarding to be original and create your own.

Flash gives you the capability to go beyond the creation of vector graphics and add the element of interactivity to them.

Button Symbols

1 In Flash, a **Button** is a re-usable **symbol** that can trigger an **action** when it is clicked on. The action could be one of the following:

- start to play or stop a sound;
- jump to another frame;
- play a new scene;
- go to a web site.

2 Button designs can take different forms. Here are some examples of button design themes:

- **Organizational** – They could relate to the organization of your site and have words on them so that the user is very clear about what the button does.

- **Functional** – They could relate to objects in the real world so that it is clear how they are used, for example, looking like a 'play' button or a doorbell.

- **Aesthetic** – Finally, button designs can be taken from the overall design theme and be small versions of a general motif.

3 If you go to **Window** > **Other Panels** > **Common Libraries** > **Buttons**, you will find many button files for you to experiment with.

Sample Buttons from the Common Libraries

Libraries

1 A **Library** is where symbols, like buttons, that you create are kept. If
 you can't see the **Library** panel then go to **Window** > **Library** or
 CMND/CTRL + L.

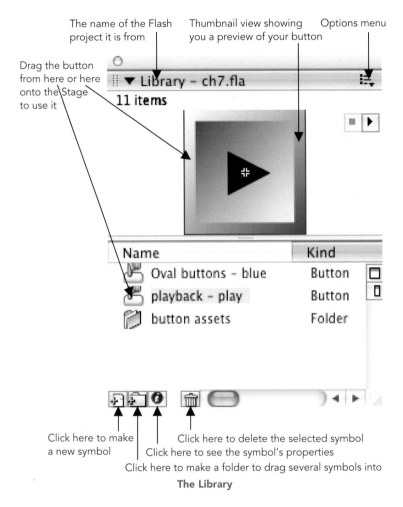

The name of the Flash Thumbnail view showing Options menu
project it is from you a preview of your button

Drag the button
from here or here
onto the Stage
to use it

11 items

Name Kind
 Oval buttons – blue Button
 playback – play Button
 button assets Folder

Click here to make Click here to delete the selected symbol
a new symbol Click here to see the symbol's properties
 Click here to make a folder to drag several symbols into
 The Library

2 If you click on the **Name** column heading, the symbols will be shown in
 order of their names. The same will happen for **Kind** if you click on that
 column heading.

3 You can use the **UP** and **DOWN** arrow keys to move up and down in the list of symbols.

Creating a Button Symbol

1 Start off by making a new symbol: **Insert > New Symbol** and add the settings shown in the diagram below:

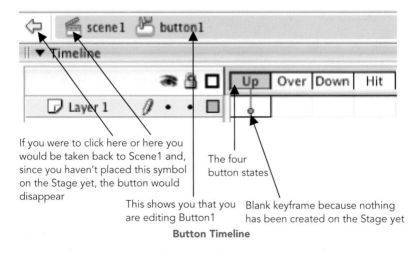

Creating a New Symbol

2 The first thing you may notice is that the Timeline looks different and that it says *Scene1 Button1* on the left-hand side of the **Edit Bar**.

If you were to click here or here you would be taken back to Scene1 and, since you haven't placed this symbol on the Stage yet, the button would disappear

The four button states

This shows you that you are editing Button1

Blank keyframe because nothing has been created on the Stage yet

Button Timeline

3 A Button symbol has four frames in its Timeline and they represent the following states:

- **Frame 1 – UP** = how the button looks when the mouse/cursor is **no-where near** it;

- **Frame 2 – OVER** = how the button looks when the mouse/cursor is **over** it;

- **Frame 3 – DOWN** = how the button looks when it is **clicked** on;

- **Frame 4 – HIT** = the size and shape of the area that will **trigger a response** when the mouse/cursor interacts with it. This shape must always be a solid filled shape.

4　If all of these four frames are the same, then you have a simple button. If each is different then the button will change with user interaction: in other words it will be a rollover button.

5　You can create **invisible buttons** by only having a solid shape in the **HIT** state and none in the other three frames. This can be useful for placing over an illustration to trigger a response.

6　Start off by creating a basic button design on the stage with the **Up** frame selected. The cross hair in the center of the Stage represents the center of the button, so make sure your design takes this into consideration.

7　In order to change the button **states** in the four different frames you will need to insert a **keyframe** to record the changes between frames. Click in the second **Over** frame and choose **Insert** > **Timeline** > **Keyframe**.

8　The **Over** frame is now filled with a black dot showing you that it contains a keyframe. Until you change it, this keyframe has the same contents as the one before, that is, your **Up** frame button design.

9　Click on the background of the Stage to deselect the shape and then change the color of your button.

10　Repeat the process on the **Down** frame. When a frame is selected, the keyboard shortcut **F6** will also **insert a keyframe** and **F7** will create a **blank keyframe**.

11　Finally, create a keyframe for the **Hit state**, but this time just create a filled solid that will cover the whole area that the user will click on to trigger this button.

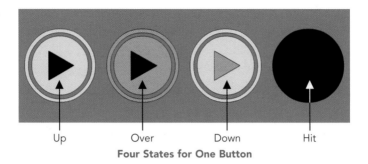

Up Over Down Hit

Four States for One Button

12 Exit the Button symbol by clicking on the word Scene1 on the Edit Bar and go back to the main Stage. Make sure that you can see the **Library** panel. Select to **Window** > **Library** or **CMND/CTRL** + **L** if it is not visible.

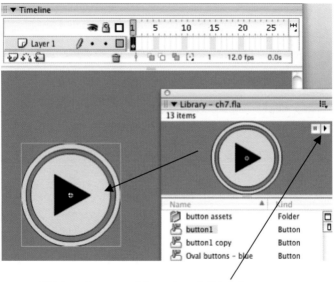

Click here to see a quick preview of all four frames

Drag a Copy of the Button onto the Stage

13 Drag a copy of the Button symbol onto the Stage from the Library panel's thumbnail and re-scale it if necessary.

14 Now to preview this button in action, select **Control** > **Enable Simple Buttons**. You are now able to move the mouse/cursor over your

button and click on it to see the difference. Deselect **Enable Simple Buttons** when you have finished otherwise you will have problems moving and manipulating your button.

What is a Symbol?

A symbol is a re-usable object that is saved in the Library panel. You can drag copies of it onto the Stage to use in your movie. A copy of a symbol used on the Stage is known as an **instance** of the original symbol.

It is good practice to name all button symbols with the prefix 'btn' – for example, **btnBack** or **btnPlay**. This will help you or any programmers that you may be working with to quickly identify the type of symbol.

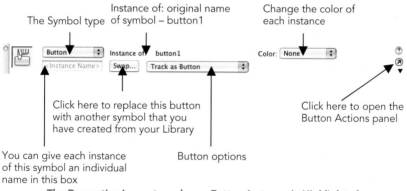

The Properties Inspector when a Button Instance is Highlighted

If you make several copies of one button symbol, it is good practice to give each one a name related to its function. This can be done in the Properties Inspector.

Each individual instance can be re-colored and made transparent with the **color** options in the Properties Inspector. They can also be rotated and re-sized with the **Free Transform** tool. These changes do not alter the source symbol in the Library.

As well as creating a symbol from the beginning with **Insert > New Symbol**, you can also select a piece of artwork on your Stage and choose **Modify > Convert to Symbol**.

You can tell that your artwork has been converted into a symbol because if you select it, it will have a blue bounding box and you can now longer use the **Eraser, Ink Bottle** or **Paint Bucket** tools on it or change the **stroke** and **fill** colors. You can no longer use the **Lasso** or **Subselection** tools to select small sections of this symbol, nor can you reshape the outline with the **Arrow** tool.

It is possible to alter a symbol after it has been created. There are several ways to enter **Edit Symbol mode**:

- double click the symbol's icon in the Library to open the symbol in isolation;

- select the symbol in the **Library** panel and then **Edit** from the **Options** menu at the top right-hand side;

- double click the symbol on the Stage to edit it in the context of the rest of your design on the Stage. This is a shortcut for **Edit > Edit in Place**, which allows you to see your scene in the background while you are editing.

To exit **Edit Symbol mode**, click on the word Scene1 on the left of the Edit Bar to go back to the main Stage.

What is a Keyframe?

Keyframes are used to record changes over time.

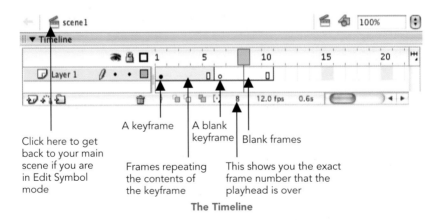

The Timeline

When you **insert** a **keyframe**, you actually create a copy of the last keyframe on the layer, which you can then change.

This is done by clicking on the Timeline into the frame in which you want to insert a keyframe and then selecting **Insert** > **Timeline** > **Keyframe**. You can also hit **F6** on your keyboard or **CTRL/RIGHT-CLICK** on the frame and select **Insert Keyframe** from the menu.

If, instead, you choose **Insert** > **Timeline** > **Blank Keyframe** or **F7**, you will insert a blank keyframe with nothing on it and you can start a new drawing.

If you want to show a keyframe for more than one frame without any changes taking place, then you don't need to insert any more keyframes, but to use **frames** instead. To insert a frame, click on where you want it to be on the Timeline and then choose **Insert** > **Timeline** > **Frame** or hit **F5** on the keyboard.

What is a Behavior?

Interactivity is created in Flash using a language called **ActionScript**. This can be complicated to learn and so Macromedia have provided a number of pre-written scripts called **behaviors** for beginners or those with a phobia for programming.

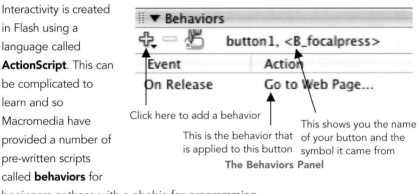

Click here to add a behavior

This is the behavior that is applied to this button

This shows you the name of your button and the symbol it came from

The Behaviors Panel

If you can't see the **Behavior** panel, go to **Window** > **Development Panels** > **Behaviors**.

Step by step to Create a Links Page

In this exercise, we will create a Links page for a web site.

1　Follow the steps earlier in this chapter to create a button symbol or use one of the designs that come with Flash in **Window** > **Other Panels** > **Common Libraries** > **Buttons**.

2 Drag a copy from the Library onto the Stage.

3 Hold down the **ALT** key and drag on the button to create copies of it. Make a button for each link you want to use. Place them on the left-hand side of the Stage in a vertical line.

4 Select all of the buttons and use the **Align** panel to space them equally. If you can't see the **Align** panel, go to **Window** > **Design Panels** > **Align** or more simply **CMND/CTRL + K**.

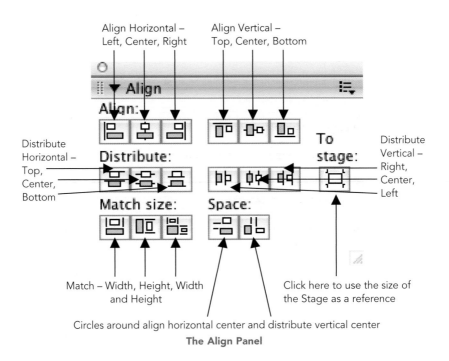

The Align Panel

5 Making sure **To Stage** is **not** selected, click on **align horizontal center** and **distribute vertical center**. Your buttons should now be perfectly positioned.
Click on the background of the Stage to de-select them.

Name Each Button

6 Select the first button that you want to add a link to and give it a name that will remind you of its function in the Properties Inspector.

Click here to Add a Behavior

7 Open the **Behavior** panel, if you can't see it, go to **Window > Development Panels > Behaviors**. Click on the plus sign to add a behavior and choose **Web > Go to Web Page**.

Add the *full* address here **Go to URL**

How the new page will open:

_self = will open in the current window and your web site will be closed.

_blank = will open in a new window so that your web site will still be open in a window underneath.

_parent = if you have frames in your web site then the new page will open in the parent frame.

_top = if you have frames in your web site then the new page will open in the top-level frame of the current window.

8 Type in the full address of the link you want to open. You can copy and paste this information from the address bar of your favorite internet browser.

9 .html is the file extension for a **HTML** page commonly exported by a Mac. **.htm** is the same file type, but this extension is more commonly used with the Windows system. Both extensions can be read by both platforms, so this is a minor detail. However, in web design you must be 100% accurate when using file names to link to other pages, so whichever you use, be consistent.

10 Choose **Open in** > **_blank** so that your web site will still be open on the users computer.

11 Select each button in turn and repeat the process until each one has a **Go to Web Page** behavior attached to it.

Using Snap Align to Position Text Next to the Buttons

12 Create text for the page and, making sure that **View** > **Snapping** > **Snap Align** is selected, move it around the page and use the guide to align the text with the buttons.

13 Create other design elements to make your links page look exciting. Make sure you are regularly saving this Flash project.

14 Now to test it. Go to **Control** > **Test Movie**. This creates a test version of your movie in the form of a .SWF file. It will be named after the name that you have given the project and will be saved in the same folder in which you have saved your project. Even though this is only supposed to be a test version, it is in the correct format to put straight into a HTML page and go live on the Internet. We will look at this process in more detail in Chapter 14.

As well as adding links to buttons, it is very straightforward to add a URL to text in Flash. It is done at the bottom of the Properties Inspector for the text tool.

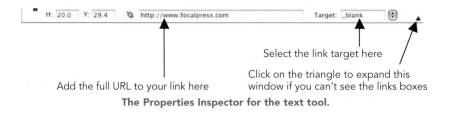

Select the link target here

Add the full URL to your link here Click on the triangle to expand this window if you can't see the links boxes

The Properties Inspector for the text tool.

Select some text to add a link to and type in the full address in the **URL link box** in the Properties Inspector for the text tool.

www.focalpress.com

Text with a Link Applied has a Dotted Line Underneath

Using Movie Clip Symbols

In addition to **button symbols**, there is a second type of symbol called a **movie clip symbol**. These are like Flash movies within Flash movies with their own layers and timelines. They are independent of the main Timeline, for example, they could be triggered by a user interaction like clicking on a button.

Movie clip symbols can be thought of as rebellious symbols that refuse to conform to the rules of the Timeline they are placed in.

We will now look at using **movie clip symbols** to create a button that animates when you hold the mouse over it.

Step-by-step Animated Rollover Buttons

1 First of all we will create a small piece of animation inside a movie clip. Go to **Insert > New Symbol**, choose **Movie Clip** as the **behavior** and give it a name that will remind you of its content.

2 It is best practice to name your movie clip symbols using the prefix 'mc', for example *mcArrows*. Using a consistent convention like this will make sure that all of your movie clips will be grouped together in your library and will make any programmer that you are working with happy.

Create New Symbol	
Name: mcArrows	OK
Behavior: ⦿ Movie clip	Cancel
○ Button	
○ Graphic	Advanced

Creating a Movie Clip

3 Create a basic button shape. Name the layer after the type of shape you have created and **lock** this layer. In this example the button shape is a rectangle.

4 Add a second layer, make sure it is the top layer and create a small triangle on it in a contrasting color. Name this layer *'triangle'*.

5 The idea now is to create a small animation of this triangle moving across the button shape that can loop endlessly over 10 frames.

▼ Timeline			👁 🔒 ☐	1		5		10		15
🗋 triangle	∅	• • ☐		•						
🗋 rectangle		• • ■		•				▯		

Extend the Button Shape Layer by 10 Frames

6 The overall button shape itself will not be moving, so its layer does not require any further keyframes, but as we do want to see it for the whole 10 frames will need to **insert frames**. Click in frame 10 of the button shape layer and select **Insert > Timeline > Frame** or more simply **F5**, so that your button shape layer now lasts for 10 frames.

7 Click in frame 10 of the *triangle* layer and select **Insert > Timeline > keyframe** or more simply **F6** to insert a keyframe. By inserting a keyframe in frame 10, there are now two identical keyframes on frames 1 and 10, so the start and end of this animation is the same.

8 Click in frame 2 of the *triangle* layer and **insert a keyframe**. The triangle shape is selected by default so just use the **RIGHT** arrow key on your keyboard to nudge it along to the right.

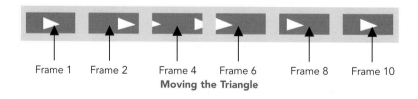

Frame 1 Frame 2 Frame 4 Frame 6 Frame 8 Frame 10
Moving the Triangle

9 **Insert a keyframe** in frame 4, nudge the triangle further along until its center is in line with the edge. Use the **Selection** tool (**V**) to drag out a

marquee and select the overlapping excess that is outside the button's outline. Drag that piece over to the left-hand edge of the button shape.

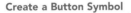

The Keyframe Positions

10 On frame 6, insert a keyframe and align the triangle with the left edge. On frame 8, insert a keyframe and nudge the triangle further to the right.

11 In order to preview how this will look when it is looping, select **Control > Loop Playback** and then hit the **RETURN/ENTER** key to play. To stop it playing, hit **RETURN/ENTER** a second time.

12 This **movie clip symbol** is going to be placed within a **button symbol** to create an animated rollover button. But first, in order to maintain continuity in the overall button shape and color, go to frame 1 and unlock the button shape layer. Now select both the triangle and the button shape and **Edit > Copy**.

Create a Button Symbol

13 Go to **Insert > New Symbol**, choose **Button** as the **behavior** and give it a name that will remind you of its content.

14 Click in the **Up** frame and select **Edit > Paste in Place**. Next select the third **Down** frame and **insert a keyframe**. De-select by clicking on the background of the Stage and change the color of the triangle to match the background of your Stage.

15 Make sure that your **Library** panel is open. Click in the second **Over** frame and **insert a blank keyframe**. Drag your **movie clip symbol** onto the Stage from the **preview thumbnail** in the **Library**.

Aligning the Crosshairs

16 Zoom in and use the arrow keys on your keyboard to make sure that the movie clip's central crosshair is exactly over the central crosshair of the button symbol.

17 **Insert a keyframe** into the fourth **Hit** frame and while the whole shape is selected choose black as the color for both the **fill** and **stroke color controls**. The whole of the button should be a solid black color now.

18 Click on **Scene 1** in the **Edit Bar** to return to the main Stage. Drag a copy of the **button symbol** that you have just created out of the Library and onto the Stage.

19 Select **Control > Test Movie** to preview your button in action. You can exit from the **Test Movie** window by clicking on the **X** in the top corner of this window – just as you would to close a window in any other program.

You could also apply a behavior to this button now, just like earlier in this chapter.

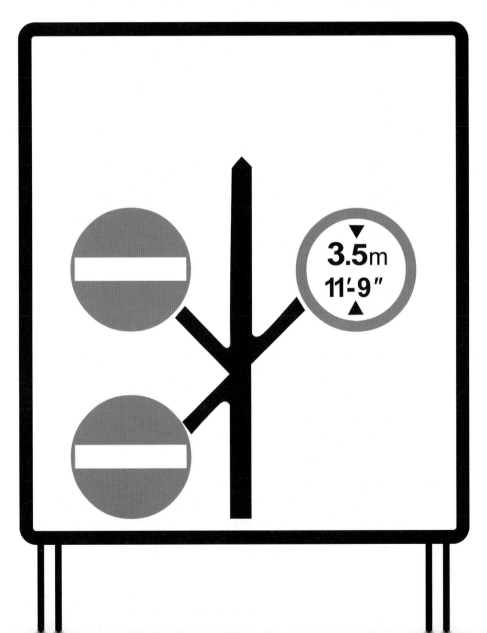

In this chapter we will look at using buttons in groups as menus.

Button Actions and Frame Actions

For people who are learning Flash or are scared of ActionScript, Macromedia have provided not only **Behaviors** – complete mini scripts that you can customize, but also **Actions** – pre-written pieces of code that you can combine and customize for your own requirements.

Actions can be attached to frames as well as to buttons, for example, to pause on a frame or for making a new movie load or to loop a sequence.

Movie clip symbols and **frame actions** can be contained within **button symbols** to create a more complex piece. However, you cannot put **button symbols** within **button symbols**.

We will now look at creating a simple menu using frame actions and behaviors.

Creating a Basic Menu

1 Follow the steps given in Chapter 6 to create a simple button and call it **btnNumbers**. Drag a copy onto the Stage.

2 Hold down the **ALT** key and drag out two copies of this button. Use the **Align** panel to make sure that they are evenly spaced.

3 Name this layer '*buttons*' and then add a second layer above called '*btnText*. Lock the *buttons* layer.

4 Using the **same** color as your background, type the word **HOME** and position it over the first button. Using a **contrasting** color, type the word **HOME** again, make the font size very large and position this on the other side of your page.

The First Frame

5 Using this same **contrasting** color, type in **5** and then the word **END**.
Place each of these over the other two buttons.

6 The text is going to change in color and content over time but the basic
buttons will not, so the *buttons* layer just needs frames – not keyframes.
Click on frame 10 of the *buttons* layer and **F5** to **insert frames**.

Frame 5

7 **Insert a keyframe** on frame 5 of the *btnText* layer. Delete **HOME**, add **5**
and change the text colors as per the diagram above.

Frame 10

8 Insert a keyframe on frame 10 of the *btnText* layer. Delete 5, add END and change the text colors as per the diagram above.

9 Now lock the *btnText* layer so that you do not alter it by accident. Unlock the *buttons* layer so that you can add some interactivity to the buttons.

10 Select the home button and name it *btnHome* in the Properties Inspector. Open the Behavior panel – Window > Development Panels > Behaviors or SHIFT + F3.

Bring Forward	▼ Behaviors	
Bring to Front	✛ ━ ⚒ B numbers <B home>	
Duplicate Movieclip	Data ▶	
Goto and Play at frame or label	Embedded Video ▶	it
Goto and Stop at frame or label	Media ▶	
Load External Movieclip	Movieclip ▶	
Load Graphic	Projector ▶	
Send Backward	Sound ▶	
Send to Back	Web ▶	
Start Dragging Movieclip		
Stop Dragging Movieclip		
Unload Movieclip	▶ Library - ch8.fla	

Goto and Stop Behavior

11 In the Behavior panel, click on the plus sign to add a behavior and choose Movieclip > Goto and Stop at frame or label.

Goto and Stop at frame or label

Choose the movie clip that you want to stop playing:

this

🖼 _root

○ Relative ○ Absolute

Enter the frame number or frame label at which the movie clip
should stop playing:

1

Cancel OK

Goto and Stop on Frame 1

12 Make sure you have all of the same settings as the diagram above. This
means that when you click on this button, it will take you to frame 1.

13 Select the **5** button next, name it *btn5* in the Properties Inspector and
add the **go to and stop at frame or label** behavior to it as before.

Goto and Stop at frame or label

Choose the movie clip that you want to stop playing:

this

🖼 _root

○ Relative ○ Absolute

Enter the frame number or frame label at which the movie clip
should stop playing:

5

Cancel OK

Goto and Stop on Frame 5

14 Make sure you have all of the same settings as the diagram above. This button will take you to frame 5.

15 As well as using this behavior to go to a frame number, you can also give a frame a name and go to the frame label. This is especially useful if you have a complicated site with lots of frames.

16 Add another layer and call it *labels&actions*. Click in frame 10, **insert a blank keyframe** and type **end** in the Properties Inspector.

Type 'end' in the Properties Inspector

17 Select the **End** button next, name it *btnEnd* in the Properties Inspector and add the **go to and stop at frame or label** behavior to it as before.

Goto and Stop on Frame 'End'

18 Make sure you have all of the same settings as the diagram above. This button will take you to the frame called '**end**'.

19 Control > **Test movie** to test out your project so far. Did you spot the deliberate mistake? The test movie is looping through the frames instead of starting out with a static frame. This can be corrected by the use of a frame action making the movie pause on the first frame.

Sound: None

Effect: None Edit...

Click here to Open the Actions Panel

20 Click in frame 1 of the *labels&actions* layer and then click on the small, circled arrow in the Properties Inspector to open the Actions panel. Don't feel intimidated by this panel, you really do not need to know everything it contains at this stage.

▼ Actions – Frame

📰 Global Functions
 📰 Timeline Control
 ⊘ gotoAndPlay
 ⊘ gotoAndStop
 ⊘ nextFrame
 ⊘ nextScene
 ⊘ play
 ⊘ prevFrame
 ⊘ prevScene
 ⊘ stop
 ⊘ stopAllSounds

stop();

The Stop Action

21 Double-click on the folder **Global Functions** to open it and then on the folder **Timeline Control** to open that. Finally, double-click on the action 'stop' to apply it to this frame.

22 A handy little shortcut – when the Actions window is open, pressing **ESCAPE** on your keyboard then **S** then **T** will add the **Stop** action.

23 The **Options** menu in the **Actions** Panel contains **View Esc Shortcut Keys**. If you select this option you will see shortcuts beside the different functions on the left-hand side.

24 Control > **Test** movie to test out your project again. This time the buttons all work and the movie stops on the frame it is supposed to stop on.

Menus and Submenus

An online portfolio is an excellent way to showcase your work. It should be easy to access information on it and for clients to view examples of your work.

The following exercise will allow you to create a pop-up menu for an online portfolio with four basic sections:

- **Home** – on which your contact details are shown;

- **Gallery** – from which you can view images,

- **About** – which contains text about yourself,

- **Links** – a selection of your favorite links.

Each of these basic sections can be divided into further categories or 'submenus'. Create your own design concept and customize this basic structure to suit your own needs.

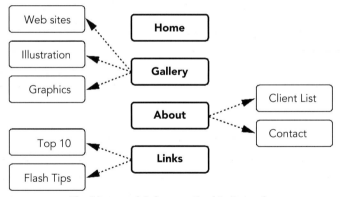

The Menu and Submenus in this Example

1 First of all, decide on the size that your overall site will have and the color scheme that you will be using and **modify** your **document** accordingly.

2 The aim is to create a site with a pop-up menu – a menu in which subcategories pop up when you click on one of the main buttons. This whole menu will be placed in a movie clip symbol.

3 First create the generic buttons which will be used in the menu. Text will be added to them on the Stage later, so do not create any text within the button at this point.

4 **Insert** > **New Symbol** > **Button** and call it *'btnMain'*. Design a plain button, **without any text**, which will be for the four main sections or the **top level** of your menu.

5 Now create the **Over** and **Hit** frames. Do this by adding a key frame to the **Over** and **Hit** frames. Then modify the graphic in the **Over** frame. Remember that the **Hit** frame only needs a filled solid shape as all it is doing is defining the area to respond to a mouse click. You don't need to add a **Down** state for this button.

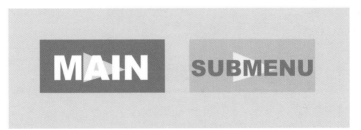

Generic Main Menu Button – *'btnMain'* – and Generic Submenu Button – *'btnSub'*.

6 Next, create another **plain** button, which we will use for the items in the **submenu** that you will see when you hold the mouse over one of the main buttons. To maintain design continuity, make this button similar in some way to the previous button. Call it *'btnSub'*. As you have already done add the **Over**, also the **Down** and **Hit** frames.

7 Now create a movie clip in which the whole pop-up menu system will be contained: **Insert** > **New Symbol** > **Movie Clip** and call it *'mcMenu'*.

8 Within this *mcMenu* movie clip, rename **layer 1** as *'btnMain'*. This is the layer on which the four main section buttons will be placed. Drag a copy of the *btnMain* button out of the Library.

9 Hold down the **ALT** key and drag out three copies. Position all four buttons in a row at the left of your Stage and use the **Align** panel to make sure that they are equally spaced.

10 Next create a new layer and call it '**btnText**'. As in the exercise before, create the text for your four buttons – HOME, GALLERY, ABOUT and LINKS and place it on top as in the diagram above.

11 Next we will create the submenu – the buttons that you will see when you hold the mouse over one of the main buttons.

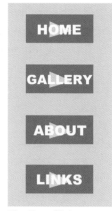

The Four Main Buttons with Text Placed on a Layer Above

12 Create two more layers and name them '**labels&actions**' and '**btnSub**'. Make sure that they are in the order shown in the diagram.

13 Click in frame 30 of the **btnMain** layer and press **F5** to create frames. These buttons will not be changing so you do not need to add keyframes on this layer. Lock this layer so that you don't move the buttons around by mistake.

▼ Timeline

labels&actic	•	•	▦
btnText	•	•	▦
btnSub	•	•	☐
btnMain	✎	•	▦

Layer Order

Click in Frame 1 and Add the Following from the Actions Panel

14 As in the previous exercise put a **Stop** action into frame 1 of the **labels&actions** layer.

15 Now select frame 10 of the top three layers only and **insert a keyframe**. Click into this keyframe for the *labels&actions* layer and name the frame *'gallery'* in the Properties Inspector.

Frame

gallery

Naming the Frame

16 Now click on the *btnSub*, layer so that it is the active layer, and drag in a submenu button for each type of work that you do.

The Gallery Submenu **The About Submenu** **The Links Submenu**

17 Add text for each of these new buttons in the *btnText* layer and change the color of the **GALLERY** text.

18 Add keyframes on the top three layers on frame 20. Repeat the process above naming the frame on the *labels&actions* layer *'about'* and creating categories about yourself.

19 Add keyframes on the top three layers on frame 30. Repeat the process above naming the frame on the *labels&actions* layer *'links'* and creating categories for your links. Add five more blank frames after *'links'* so you can see the label.

The Layers and Labels

20 We have added the basic buttons – the next step is to make them actually work. Go back to frame 1. Unlock the *btnMain* layer and lock the other three layers.

21 Select the **HOME** button. Name it *btnHome* in the Properties inspector and select the **track**

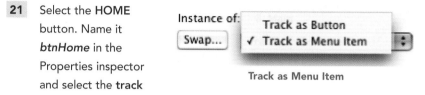

Track as Menu Item

as menu item option. This allows the buttons to act as a group. It means other buttons can receive mouse event information.

22 As in the previous exercise, click on the **plus** sign in the **behaviors** panel and choose **Movieclip > Goto and Stop at frame or label** to apply this behavior. Make sure (*'mcMenu'*) is selected as the **movie clip** and it says **1** in the frame number/label field.

23 Click on the **mouse event type** in the Behaviors panel and select **On Roll Over**. This means that the user will be taken to the new frame when they hold the mouse over this button. They will not need to click on the button to activate it.

Event	Action
On Roll Ove ▼	Goto and Stop at frame or label...
On Drag Out	
On Drag Over	
On Key Press	
On Press	
On Release	
On Release Ou	
On Roll Out	
On Roll Over	

The Mouse Event Types

24 Select the **GALLERY, ABOUT** and **LINKS** buttons in turn and name each one in turn in the Properties Inspector as *btnGallery*, *btnAbout* and *btnLinks*. Then make sure that **track as menu item** is selected for each one.

25 Finally, apply the **Goto and Stop at frame or label** behavior to each one, making sure that the **GALLERY** button is going to the **gallery** frame label, the **ABOUT** button is going to the **about** frame label and the **LINKS** button is going to the **links** frame label.

Goto and Stop at frame or label

Choose the movie clip that you want to stop playing:

this

▼ _root
 (menu)

(◄ ►)

● Relative ○ Absolute

Enter the frame number or frame label at which the movie clip
should stop playing:

gallery

(Cancel) (OK)

Goto and Stop Behavior Applied to the Gallery Button

26 Select **On Roll Over** for each button.

27 Click on **scene 1** in the Edit Bar to go back to the main Stage and out
of the *mcMenu* movie clip. Drag a copy of this *mcMenu* movie clip out
of the Library and onto the Stage.

Movie Clip Instance of: mcMenu

mcMainmenu Swap... **Name the Movie
Clip**

28 In the Properties Inspector, name this movie clip *'mcMainmenu'*.
Control > Test Movie to look at this menu so far.

An Online Portfolio

In the previous exercise, you completed a menu system that was contained
within a movie clip.

Once this menu movie clip is on the Stage, you can use it to control events on the Stage:

1 On the Stage, create a *'labels&actions'* layer. Place new blank keyframes with labels at regular intervals for every single submenu item.

Target Frames for the Submenu Buttons

2 Following on from the previous example you would need to create labelled keyframes for all of the following:

- home,

- web sites,

- illustration,

- graphics,

- client list,

- contact,

- top 10,

- flash tips.

3 Add content to each of these frames for the submenu buttons to link to.

But how do you connect the buttons *within* the movie clip menu to labelled frames on the *Stage*? Don't they have different Timelines?

4 Double click on your menu movie clip on the Stage to open it in Edit Symbol mode.

5 Select the button in your menu that you want to link to a frame on the main Stage. Add the Goto and Stop behavior to it.

94

Goto and Stop at frame or label

Choose the movie clip that you want to stop playing:

```
this._parent
```

▼ 🖼 _root
 🖼 mainmenu

◉ Relative ○ Absolute

Enter the frame number or frame label at which the movie clip

should stop playing:

```
home
```

 (Cancel) (OK)

Linking a Button Within a Movie Clip Menu to Open a Frame on the Main Stage

6 Make sure **_root** is selected as the movie clip and type in the name of the frame. This means that you will go to that frame on the main Stage.

Loading Images

For your Gallery page, if you were to create a Flash movie and put lots of jpeg images in it, you could end up with a very large file size and clients may not have the patience to wait for it to download. So instead of **embedding** images within this site, we are going to look at using buttons and behaviors to **load** an external image onto a target on your page.

1 In order for this to work simply, all your images must be **jpegs** that you have previously optimized and cropped to the **same size** as your **target** using an Image Editing program like Fireworks or Photoshop. In this example, the target and the image sizes are all 390 × 290 pixels, but this will vary according to your design.

2 Another way to keep this whole process very simple is to make sure that all of your jpegs are in the **same folder** as your Flash project and final Flash movie.

3 Next create a new movie clip symbol, which is a simple rectangle and call it *'mcTarget'*.

The Image Target and Buttons

4 Make sure that the top left-hand corner of the rectangle snaps onto the crosshair in the center point of the symbol. If you do not do this then your image will not load correctly.

5 Then drag a copy of *'mcTarget'* into your main movie. You can check the pixel dimensions of this movie clip in the **Info** panel – **CMND/CTRL + I** if you can't see it.

6 Select the *mcTarget* movie clip and name it *'mcImage_target'* in the Properties Inspector. Then select **Alpha** from the **color pop-up** in the Properties Inspector and set this to 0% to make it transparent.

Align the Top-right Corner of the Rectangle with the Center Point of the Symbol

The Properties Inspector for the Movie Clip

7 Next create a series of buttons, each of which is going to open up a new image into the *'mcImage_target'* movie clip.

8 Select the first of
the image buttons.
Give each one its
own name in the
Properties Inspector.
Add the behavior
**Movieclip > Load
Graphic** to each
button and the file
name of the image
that you want it to
load.

		Behaviors
		⊕ ⊖ 🔀 R im:
		Data
		Embedded V
		Media
Bring Forward		Movieclip
Bring to Front		Projector
Duplicate Movieclip		Sound
Goto and Play at frame or label		Web
Goto and Stop at frame or label		
Load External Movieclip		
Load Graphic		
Send Backward		
Send to Back		
Start Dragging Movieclip		
Stop Dragging Movieclip		
Unload Movieclip		

The Load Graphic Behavior

Load Graphic

Enter the URL to the .JPG to load:

myjpg.jpg

Select the movie clip into which to load the graphic:

this.image_target

▼ 🖼 _root
 🖼 image_target
 🖼 mainmenu

◉ Relative ○ Absolute

Cancel OK

The Load Graphic Window

9 Make sure that *mcImage_target* is selected as the movie clip into which
to load the graphic. Remember that your jpeg file *must* be in the same
folder as your Flash project for this to work.

10 We will also need to make sure that each time you load a graphic, you close the one that was previously opened, so we will need to add a second action to each of the image buttons as below.

The Unload Movie Behavior

11 Select *mcImage_target* as below.

The Unload Movie Window

12 We just need to alter the order of these two behaviors now, so that the previous image is unloaded before the new image is loaded.

‖ ▼ Behaviors	📇
➕ ➖ 🔖 B_image, <B_1>	△ ▽
Event	Action
On Release	Load Graphic...
On Release	Unload Movieclip...

With the Unload Behavior Selected, click on this Triangle to Alter the Order

‖ ▼ Behaviors	📇
➕ ➖ 🔖 B_image, <B_1>	△ ▽
Event	Action
On Release	Unload Movieclip...
On Release	Load Graphic...

The Behavior Order is Now Changed

13 Make sure that you are saving regularly!

'Mail to' Link

Finally, after all of your hard work, you will want people to be able to contact you through your web site. This can be done through a text link or a button using *'mail to'*. When this type of link is clicked on, the users email program will open on their computer and they will be able to send you an email directly.

Adding Mail to

To add a *'mail to'* to text, highlight the text you want to add this link to and add **mailto:** followed by your full email address in the **URL links** box in the Properties Inspector as above.

Go to URL
URL: mailto:me@focalpress.com
Open in: "_blank"
Cancel OK

Adding a Mailto with Goto URL

In order to attach a *'mail to'* to a button, use the **Go to URL behavior** and type the text in exactly as above.

CHAPTER 8

ANIMATION

Animation is the illusion of movement caused by a sequence of pictures changing rapidly over time. Due to a process known as the 'persistence of vision' our eyes are tricked into seeing these still images as being in motion rather than as individual pictures.

To create animation with Flash you also create a series of still images – on the Stage – and change them over time. A change is recorded by a **keyframe**, so each time you move, redraw, rotate, etc. your drawings on the Stage you will need to create a **keyframe** to save all the different drawings in your sequence. You will then be able to play them back and see your drawings come to life.

There are two different ways to produce animation in Flash. The first is very intuitive. **Frame-by-frame animation** involves drawing each frame individually. The second may seem more complex, but once you have grasped the concepts of animating with **tweening** you will be able to save yourself a lot of time.

Creating a Banner Ad with Frame-by-Frame Animation

1. Start a new Flash Project. **Modify** your **document** so that it is 468 × 60 pixels in size with a frame rate of 15 frames per second.

2. A good length for a banner ad is three seconds, so try to keep all your animation within a duration of 45 frames.

3. Experimenting with the different drawing tools and the marks they make, design a background – either a landscape or a pattern, which will not be animated. Name this layer **background** by clicking twice on the existing layer name. Lock this layer if you do not want to change it again.

Separating and Locking Layers

4. Make a new layer by selecting **Insert** > **Layer** or by clicking on the + icon at the bottom left of the Timeline.

5. Draw a character or shape or text to be animated on this new layer and name the layer appropriately so that it is easy for you to remember what is on each layer.

6 You could also import bitmaps onto different frames and move them around.

The Layer That is at the Top of the Stack of Layers in Your Timeline will be in the Foreground of Your Animation. The Bottom Layer will be in the Background

7 If you have several elements on one layer, you can get Flash to automatically put them on separate layers by first selecting the layer and all its contents and then the command **Modify > Distribute to Layers**. If your shapes overlap, they will not be put on separate layers, but thought of as one element.

8 To re-order the layers you just need to click onto the name of the layer and drag it either up or down.

Using Keyframes

9 In order to do frame-by-frame animation, you'll need to remember to **insert** a new **keyframe** every time you want to change the drawings on the Stage.

10 Move ahead in the Timeline by 1 or 2 frames, click on a keyframe to select it and **Insert > Timeline > Keyframe** or **F6** for the layer that you want to animate. This will copy the keyframe before and you can now alter it. If you choose **Insert > Timeline > Blank Keyframe** or **F7**, you will insert a totally blank keyframe and you can draw from scratch.

11 The amount of keyframes that are used will affect the smoothness of your action. If you want your action to be fast and smooth – put a

keyframe on every frame. For normal action you can probably get away with putting a keyframe on every other frame.

12 When you see a black dot on the Timeline you know you have a keyframe. However, if you have a complicated scene you may not remember what is on each keyframe. There is a way, though, to get a look at the contents of your keyframe. At the end of your Timeline is a **Frame View button**.

Tiny
Small
✓ Normal
Medium
Large

Short

✓ Tinted Frames

Preview
Preview In Context

The Frame View Button at the end of the Timeline

13 If you click on this button, you have some options as to how to view your frames. You can alter the size that they are displayed on the Timeline and you can also choose **Preview** and **Preview in Context**.

Preview shows only what is on the layer – not any surrounding empty space. Preview in Context shows what is on the layer in proportion to the whole Stage.

Onion Skinning

14 You may want to be able to refer to keyframes before and after the point in time that you are working on. You can do this by using **onion skinning**.

15 **Onion skinning** is turned on and off by selecting the little buttons at the bottom of the Timeline. You can choose to see a semi-transparent version

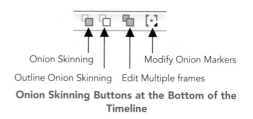

Onion Skinning Modify Onion Markers

Outline Onion Skinning Edit Multiple frames

Onion Skinning Buttons at the Bottom of the Timeline

of the other frames or an outline version. Click on the button for a second time to turn onion skinning off.

16 When you have one of the onion skinning buttons selected, you will be able to drag out the onion skinning markers at the top of the Timeline and see more or less frames.

17 If you are not happy with what you have done on a keyframe, you have two options. First select the keyframe by clicking on it in the **Timeline**. You can then choose **Edit > Timeline > Clear Keyframe**. This will delete the changes that you made on that particular keyframe and you revert back to what was on the keyframe before. You will still have the same number of frames overall.

18 Your other option is to choose **Edit > Timeline > Remove Frame**. This has a similar effect, but your overall sequence will have one less frame.

19 If you have a still image in your animation, for example, a background that won't need to move, you only need to use one initial keyframe and then extend its duration with frames.

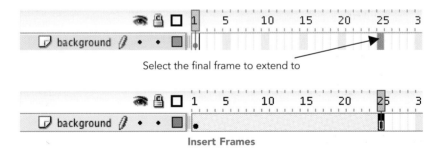

Select the final frame to extend to

Insert Frames

20 In this case, select the final frame that you want to extend to and then **Insert > Timeline > Frame** or **F5**.

21 Play back your animation by using either the **playback controls** or press **ENTER** on your keyboard. Under the **Control** menu, you can select the **Loop Playback** option if you want to see your animation played back and repeated.

Don't forget to save regularly!

Frame Rate and Size

What is frame rate? – This term refers to how many images you will be showing over time. It is measured in frames per second.

You can see the frame rate of your movie at the bottom of the Timeline measured in frames per second. Clicking on this figure acts as a shortcut to open the **Document Properties** dialog box.

If you have a high frame rate, like 25 or 30 frames per second, your animation will look smooth. If you have a low frame rate, like 5 frames per second, your animation will look jerky.

However, the accuracy of the playback depends on the speed of your CPU. Many computers cannot handle playing back your animation within Flash at 25 or 30 frames per second and will drop frames. If this is the case with your computer, you will need to export a small test movie to see your timing accurately.

How do I know what frame rate to use? – The more frames you have per second, the larger your file size will be. If you are animating for the web you most certainly do not want a high frame rate, because you want to keep your file sizes as small as possible. A standard frame rate for web animation would be somewhere between 10–15 frames per second. Experiment and choose the frame rate that works best for you.

How do I know what frame size to use? – If you are creating animations for the web, you can choose the size of your movie according to the size that you want it to be on your web page. However, there is a fixed size if you want to put your animation onto video. See Chapter 12 Video for more information about this.

Can't I Just Change These Settings After my Animation is Finished?

It is best practice to make sure you have the correct frames per second set up before you start, because it is not so easy to change once your animation is started.

For example, if you have done a 5 second animation at 15 frames per second with keyframes at 1-second intervals and then you change the frame rate to 30 frames per second, Flash won't rescale the time.

The Timeline measures time in frames not in seconds so your keyframes will still be at frames 15, 30, 45, 60, 75, but your animation will have been speeded up to last for $2\frac{1}{2}$ seconds.

Test it out for yourself!

Similarly if you enlarge your **document** size after you have finished your animation, the whole animation will have moved to the top left-hand corner.

To move it back you can use the **Edit Multiple Frames** button in the Timeline.

After you have selected this button, you will be able to see markers at the top of the Timeline. Drag them to cover all of the frames in your animation and then choose **Edit > Select All.**

Now drag your animation back to its original position. Don't forget to click the button a second time to deselect it.

Symbol Animation

Animating frame-by-frame has its advantages, as long as you can draw in perspective, you can make characters spin around and move fluidly in different directions.

Sometimes it can be hard to visualize what an object or character would look like from different directions. If you are having problems with this, I would recommend making a little model of your character and using it for reference. The disadvantage of frame-by-frame animation, however, is that is lots of hard work drawing all of those pesky frames!

Luckily there is another way to animate in Flash in which the computer does much more of the work. You can create **symbols**, which are re-usable drawings. Once you have created a symbol, you can alter it in successive keyframes, apply **motion-tweening**, and Flash will draw all the frames in-between the keyframes.

Creating Graphic Symbols and Instances

1 Draw a character or shape to be animated and name the layer appropriately.

2 This kind of animation works best if each separate item to be animated is on a different layer. So, if your character has several moving parts, each one will need a separate layer. Name each layer so that you can remember what's on it.

3 As with the **button** and **movie clip** symbols that we created earlier, **graphic** symbols can be created in two ways:

- Create your graphic on the Stage and then choose **Modify** > **Convert to Symbol. Name it and** Choose **graphic** behavior from the dialog box.

or

- Select **Insert** > **New Symbol**. After naming your new symbol and choosing graphic as its behavior, you will be presented with an empty Stage on which to create your new symbol.

4 You can give your graphic symbol any name that you feel like, however if you are working with programmers, they will be your friend if you prefix your graphic symbol names with '*g*', for example *gSpider*.

5 Just as with the **button** and **movie clip** symbols that we looked at earlier, you can find your original symbols in the Library. Your **graphic** symbol can be re-used many times in your scene, by dragging it from the **preview** window of this panel onto the Stage.

**Your Original Symbol is in the Library.
You Change Copies of it on the Stage**

6 The symbol that you see in the Library is the original version. The version of the symbol that you are using on the Stage is a copy of this original and is known as an **instance**.

7 Create a **keyframe** in frame 30 by clicking in the Timeline in frame 30 and selecting **Insert > Timeline > Keyframe** or **F6**.

8 This creates a copy of the previous keyframe, so you can see your **instance** in exactly the same position as it was in the last keyframe. You can now **move** the instance with the **Selection** tool and also **resize** or **rotate** it with the **Free Transform** tool.

Three Different Instances of the Same Symbol

9 You have other options as well. When you are on a keyframe and an **instance** is selected, you can see its property options in the Properties Inspector panel underneath the Stage. If you can't see it, choose **Window > Properties**.

Properties Inspector Panel

10 In the Properties Inspector panel you can select different values to change from the dropdown box next to **Color**.

- **Brightness** allows you to make your instance lighter or darker than the original symbol.

- **Tint** allows you to give the instance a different color than the original symbol.

- **Alpha** allows you to make the instance transparent. All three of these have a slider, which controls the amount of the effect.

- **Advanced** lets you use a combination of these.

11 So far you should have two different keyframes on your Timeline with two different versions or **instances** of the same original **symbol**.

12 If you were to play back this project so far, there would not be any animation. One image would just instantly become the other. So far there is no interpolation going on in between them.

Motion Tweening

Click on a Frame in Between Your Keyframes

13 Now click somewhere on the frames in between these two keyframes that you created earlier to select these frames. You will now be able to see the **Frame** properties in the Properties Inspector panel underneath your Stage.

14 In Flash, as in life, there are often many different ways to do the same thing and there are different ways to apply **motion tweening**. Once you know the different methods, you can choose the one that is easiest for you.

- Once you have selected the **in-between** frames in the middle of two keyframes, you can then choose **Insert > Timeline > Create Motion Tween**.

- Alternately, you can **CTRL/RIGHT-CLICK** on this point and select **Create Motion Tween** from the drop down menu.

Choosing Motion from the Tween Options in the Properties Inspector

- Finally, if you have selected the **in-between** frames in the middle of two keyframes, you can then select **Motion** from the **Tween** drop down box in the property inspector.

15 The in-between frames should now be pale blue and have an arrow pointing from one to the other.

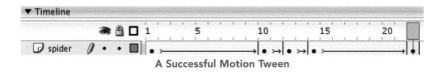

A Successful Motion Tween

16 When you see this arrow, you know that your tween has been successful. If, however, you don't see an arrow and instead see a dotted line – something has gone wrong!

17 The most common reasons that your tween may have gone wrong are:

- You forgot to use symbols – motion tweening doesn't work properly without converting your graphics to symbols,

- You have more than one symbol on your layer – again this doesn't work well,

or

- You converted your graphic retrospectively into a symbol and it changed in one of the keyframes but not in the other. The best way to deal with this is usually to select the second keyframe, choose **Edit** > **Timeline** > **Clear Keyframe** and start again.

18 Save and press **enter** to preview.

Editing Symbols

1 Although you cannot seem to alter your symbol on the Stage, it is possible make changes to it.

2 Just as with **button** and **movie clip** symbols, if you go into your **Library** panel and select **Edit** from the **Options menu** at the top right-hand side, you enter into **Edit Symbol mode**. You will now be able to change your symbol and all the copies or **instances** on the Stage will change too.

3 Be careful, because it is quite easy to start editing your symbol without realizing.

4 You should by now have got into the habit of double-clicking on a shape that you have drawn to select it, to make sure that both the stroke and fill are selected.

5 If you double-click on a symbol, however, you will find that there is no longer a blue bounding box and that your symbol can now be altered. You may also wonder where the rest of your layers have gone and why the rest of your scene appears pale. The reason for this is that you have taken a shortcut for **Edit > Edit in Place**. This allows you to edit your symbol while still seeing the rest of the Stage.

6 As before, click on **Scene 1** on the information bar at the top left of the Stage to get back to your scene.

Summary

1 So, to summarize, the simplest way to create animation in Flash is to draw each change that you want to happen on the Stage over time.

2 With this method of **frame-by-frame** animation you need to create a new **keyframe** in the Timeline every time you want something different to happen on the Stage.

3 If you want a drawing to **move, resize, rotate, change color** or **transparency** over time, you don't have to draw these changes on every

frame: you can create a re-usable piece of graphic called a **symbol** and alter it over time.

4 Each time you want this symbol to change, you will need to insert a new **keyframe** onto the Timeline. A **keyframe** is a frame on which a change takes place. Flash can create all the stages of change in between your keyframes if you use symbols. In order to instruct the computer to create all these in-between frames between your keyframes, you will need to select those frames and create a **motion tween**.

5 Your original **symbol** can be accessed in the **Library**. What you are working with on the Stage are copies or **instances** of the original graphic.

6 You can use many copies of the same symbol on the Stage at the same time, but in order to **motion tween** them *individually* in *different ways* they will all need to be on **separate layers**.

7 Motion tweened animations have smaller file sizes than frame-by-frame animations. This is because you are making alterations to a pre-defined symbol rather than starting a new piece of drawing from scratch on each frame and this information takes up less storage space on the computer.

8 Remember to make your symbol a **graphic symbol** for straightforward animation. The other types available are used for interactivity. Movie clip symbols won't play back on the Timeline properly.

CHAPTER 9

MORE ANIMATION TECHNIQUES

Using Motion Paths

A **motion path** is a drawing of the shape of the movement that you would like the symbol you are animating to take. You can draw these on **guide layers** in Flash. **Guide layers** can also be used to add lines and shapes that you are only using for layout and reference purposes. When you render your final movie, you won't see anything that has been created on a **guide layer**.

1 Draw a shape that you would like to animate and turn it into a **graphic symbol**. Make sure that it is on it's own layer. Create a second **keyframe** in frame 30 and create some **motion tweening** between these 2 frames. You need to do this so that you have more than one keyframe to place on your motion path.

Two Motion Tweened Keyframes

2 Now to create a motion path. Make sure the layer you want to effect is selected. Select **Insert > Timeline > Motion Guide** or more simply click on the **Add Motion Guide** icon at the bottom of the timeline. This will create a new layer called **Guide:** *(name of layer effected)*. The layer underneath, which will be effected by the motion guide, should be indented.

3 A guide layer won't show up in your final movie. You could also use it to write little notes and reminders to yourself or your co-workers while you are working.

4 Click on guide layer's name to make it active. Select the **Pencil** tool and the **Smooth** modifier. Draw a curved path on frame 1. If it is not smooth

Motion Guide that we Want to be the Flight Path of the Bird

enough, double click on the path (using the Arrow tool), then click on the Smooth modifier again and again until you achieve the desired result. You can draw a **motion path** with the **pencil** or **pen** tools.

5 Your motion guide layer should have been automatically extended to a length of 30 frames. If for some reason it hasn't, insert blank frames to extend it, by selecting the frames up to frame 30 and then **Insert >** **Timeline > Frame** or **F5**.

6 Turn on **snap** in the properties inspector. Then, making sure that you are in frame 1, drag your character/shape by its center point until it snaps to the starting point of the path you just drew.

The Center Point of the Bird Symbol Snapping to the Motion Path

7 Go to frame 30 and drag to the end of the motion path as above. Check that in frames 5 and 25 your object is also snapping to your path.

The Visibility of the Guide Layer is Turned Off, but Onion Skinning Shows that the Bird Symbol is now Following the Motion Path

8 Once everything is working for you, click the eye icon to the right of the Motion Path layer and select **Hidden**.

9 Save and press **ENTER** to preview.

Orient to Path Snap

Add number of rotations here
to make the symbol spin Expansion triangle

Frame Properties Inspector

10 In order to change the symbol's orientation as it progresses along the path, access the **Properties Inspector** by clicking in between two

keyframes on the timeline. This is now showing you the **frame properties** with different options for tweening.

11 Now select **orient to path**. You might need to expand your **Properties Inspector** view in order to see this option. You can do this by clicking on the small downward pointing triangle in the bottom right hand corner of this panel.

The Same Bird Example with Onion Skin Outline and Orient to Path Applied

12 You could also opt to have your symbol rotating by selecting **Rotate > CW (Clockwise)** or **(CCW) Counter Clockwise** and specifying the number of rotations.

Easing

1 When you **motion tween** between two keyframes, the changes that take place happen at a constant speed. In the real physical world, however, changes don't take place at a constant speed. If you were to kick a football, the initial force of the kick would mean that the ball would start off moving fast and then as friction, gravity etc acted on it, it would start to slow down. Flash can enable you to add a certain amount of acceleration and deceleration to tweens. This is done through **easing**.

2　Click in between two keyframes on the timeline and then look at your **frame Properties Inspector**. One of the options is called **easing**. This controls the amount of acceleration or deceleration in the changes between two keyframes. If you drag the slider down to get a negative number – this adds acceleration. Moving

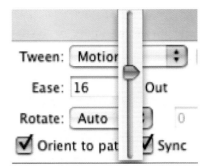

Easing in the Properties Inspector

the slider up to get a positive number adds deceleration.

Shape Tweening

So far we have looked at animating symbols with **motion tweening** so that the software creates the '*inbetweens*' for you. Flash can also transform one drawing or graphic shape into another and create the '*inbetweens*' that describe the changes from the first drawing to the second. This process is called **shape tweening**. You **do not use symbols** when you are shape tweening.

First off, the basics:

1　Start a new file. Draw a circle on frame 1. Insert a **blank** keyframe into frame 30.

2　Turn on **onion skinning** so that you can see where the circle you just drew was positioned.

3　Select the **rectangle tool**. Change the **fill color**, **stroke color** and **line style** and draw a rectangle roughly over the position of the circle. Turn **off** onion skinning.

4　On the **timeline**, click on the frames that are in between the 2 keyframes you just created so

Draw a Rectangle in one Keyframe and a Circle in Another. Use Onion Skinning to Align Their Positions

that you can see the **frame Properties Inspector**. Select **Shape** from the **Tween** menu.

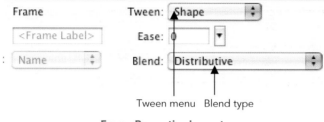

Frame Properties Inspector

5 Note that in the **Properties Inspector panel** you can apply **easing** to a shape tween just as you can to a motion tween. This will allow you to have more of the starting or ending shape shown. **Blend** refers to how the morphing will be applied: **distributive** emphasizes **curves** and **angular** emphasizes **angles**.

A Successful Shape Tween

6 The frames that you clicked in on the Timeline should now be green and there should be an arrow from keyframe to keyframe. This indicates that your tween has worked with no problems.

An Unsuccessful Shape Tween

7 If you have a dotted line between the 2 keyframes, this indicates that something has gone wrong with your tween. The most common reasons

are that you tried to shape tween (a) a symbol, (b) a group or (c) editable text (more on how to shape tween text next). None of these will work.

8 Press **ENTER** to preview.

Now let's look at shape tweening text and how to control a shape tween. This doesn't work with standard editable text. You have to break the text apart first. As the software is creating the '*inbetweens*' for you, the results may be unpredictable. However, you do have a certain amount of control over this process through the use of **easing, blend type** and **shape hints**.

1 Type your name onto a new layer with a size of 72 points.

2 Insert a **keyframe** on frame 30. Change the font that is used on this keyframe.

3 Shape tweening doesn't work for standard text so you have to turn them into editable vectors by selecting them and then **Modify > Break Apart** or **CMND/CTRL + B**. You have to do this twice and the second time you are changing the letters from editable text into a vector graphic.

The First Time You Select Break Apart you are Ungrouping the Letters

The Second Time You Select Break Apart the Letters Become Graphic Objects

4 Make sure that the text is also broken apart in the other keyframe. Select the frames between the keyframes and select **shape** for the **tweening** type from the **frame panel**.

5 Save and press **ENTER** to preview.

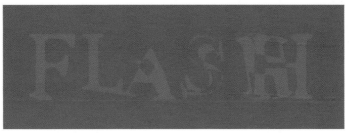

The Result May Look Quite Strange in the Middle

6 Flash may need more information about which points in the letters correspond to the same points in the second style of letters. **Shape hints** can rectify the tween.

Adding Shape Hints

7 Look at the animation carefully and work out in which places Flash becomes confused. In frame 1 select the required letter and **Modify > Shape > Add Shape Hint**. You may have to zoom out to find it and then zoom in again to place it accurately.

8 Go to frame 30 and move the shape hint to the corresponding place on the letter.

9 Keep saving, previewing and adding more shape hints until you achieve a smooth morph from one letter to another. Unfortunately, sometimes shape hints don't untangle your shape, so don't be disappointed if it doesn't work as expected.

Note: Shape tweening is an entirely different process to **motion tweening**.

Motion tweening refers to an **original symbol**. The copies or **instances** that you are working with have a relationship with the original.

On the other hand, **shape tweening** is the process whereby one image turns into another entirely **unrelated** image. To create a shape tween, therefore, you **do not use symbols**, because you are not simply modifying an original but morphing it into something totally new.

Shape tweening can be useful for animating gradients and for changing one facial expression into another.

Animated Highlights

Creating masks allows you to mask out areas of the screen. When you create a mask layer it hides part of the layer underneath. Your mask can be animated. You could use a mask layer to give the impression of looking through a keyhole or through a pair of binoculars. Beware though, spotlight effects are seen by some as a Flash cliché.

In this example, we will create an animated gradient and then put a mask in the shape of a word over it. This will give the impression that light is moving across the text.

1 First, create the text that the effect will show through.

2 Select the **text tool**, click somewhere on the stage, and type < FLASH > or another word of your choice. Use a big, bold, chunky

font so that the text looks dramatic and clearly seen. Don't spend time trying to perfect the color of your text, as it will be used as a **mask** later, and you won't be able to see its color.

3 This should be the top layer as it will be masking the layer underneath. Name this layer < **text mask** >.

4 Next to create the effect which will be showing through your text. **Insert** a **new layer**. Drag this new layer underneath the layer you just created the mask on. Name this new layer <gradient>.

Animating Gradients

5 Select the **Rectangle tool**, make sure that there will be no outline on it by clicking in the **Stroke Color Control** and clicking the white box with a red line through it. Draw the rectangle so that it stretches off screen. Then click the rectangle you just made and open the **Color Mixer panel**. If you can't see it, choose **Window > Design Panels > Color Mixer**.

6 Select **Linear** from the **Fill Style** drop down menu. Make a linear gradient that goes from gray to white to gray, dragging in the two outer tabs to make the white portion narrow compared to the rest of the gradient.

Create a Narrow Gradient for the Rectangle

7 First making sure now that your rectangle is *not* selected, choose the **Transform Fill tool** to **rotate** the 'glint' to a 45° angle. You might need to choose a magnification of 50% or even 25% in order to see the **Transform Fill handles**, which you use to rotate and re-scale fills with.

Rotate the Gradient to an Angle with the Transform fill Tool by Dragging on this Handle

Drag the Gradient Fill to the Left

8 Next drag the gradient fill all the way to the left so that the central white stripe is at the back to the left-hand side of the text.

9 We want to make it look as if the effect is moving across the text, which will stay stationary. Make a keyframe on the gradient layer at frame 30 and use the **Transform Fill tool** again to drag the gradient over to the

right hand side. Next choose *shape* tween from the **Properties Inspector** so that the gradient moves from one side of the stage to the other.

Drag the Gradient Fill to the Right

10 Select frame 30 of the text layer and **insert frame** so that the text layer exists for the same amount of frames as the rectangle. This will make sure that the text stays on the stage while the effect rolls along.

Mask Layers

11 Make sure your **gradient** layer is **beneath** your **mask** layer. Making sure that the **mask** layer is the active layer **CTRL/RIGHT-CLICK** on the **text layer** and choose **Mask** from the pop up. Your text should now be filled by the rectangle that you made.

The Highlight Travels Across the Text

12 Press **ENTER** to preview – the highlight should travel across the text.

13 Both layers are now locked. If you want to remove the masking, unlock the layer and **CTRL/RIGHT-CLICK** on the **text layer** and choose **Mask** from the pop up a second time.

14 Be creative and experiment with this basic idea, for example, import a bitmap and animate it moving behind some text, fade the 'gleam' in and out, create an animation which shows through some text.

15 You can soften the edge of the mask with the use of gradients. The mask itself can also be animated. Horizontal stripes and circles can be used to get the effect of film transitions. Finally, masks can apply to more than one layer if these are indented underneath the mask layer.

CHAPTER 10

FURTHER ANIMATION TECHNIQUES

Timeline Effects

Timeline Effects are prebuilt effects allowing you to easily create and duplicate animated **text, graphic symbols, shapes**, and **groups**, imported **bitmaps, button**, and **movie clip symbols**.

1 To apply a **Timeline Effect**, select the object you want to apply it to and then select the required Effect from the **Insert** menu.

The Copy to Grid Effect

2 Insert > Timeline Effects > Assistants > Copy to Grid creates copies in the shape of a grid.

3 **Update Preview** allows you to see the changes that you have made to the Effect perameters.

Layers are Named after the Effect Applied

4 The settings are saved within a graphic symbol that can be found in your library with the rest of your symbols and imported bitmaps.

5 If you want to separate the grid into individual pieces, then choose **Modify > Break Apart**.

6 **Insert > Timeline Effects > Assistants > Distributed Duplicate** creates copies in a line.

The New Graphic Symbols are also Named after the Effect

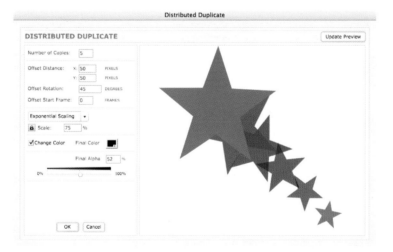

7 **Insert > Timeline Effects > Effects > Blur** is used to create an animated fade out.

8 **Insert > Timeline Effects > Effects > Drop Shadow** allows you to create a drop shadow. Entering positive numbers into the **Shadow Offset** boxes will place your shadow in the bottom left corner. Entering

negative numbers in both the **X** and **Y** boxes will place your shadow in the top right corner. Unfortunately, there is no control to allow you to rotate or skew the drop shadow, so I prefer to create them manually.

First Frame of an Expanded Text Sequence

9 **Insert > Timeline Effects > Effects > Expand**. This Effect creates an animated re-scaling. As with **Explode**, it is most successful when used with text.

10 **Insert > Timeline Effects > Effects > Explode**. This Effect gives the illusion of an explosion with pieces rotating away from the center.

11 **Transform** allows you to animate position, rotation, scale and transparency all in one go. This can be found by accessing **Insert > Timeline Effects > Transform/Transition > Transform**.

Four Stages of a Wipe Transition

12 **Transition** allows you to add a fade or wipe transition.

13 To edit your **Timeline Effect** after it has been applied, choose **Modify >
Timeline Effect > Edit**.

14 To remove your **Timeline Effect**, choose **Modify > Timeline Effect >
Remove Effect**.

Animated Symbols

When you create a **graphic symbol**, you may have noticed that it contains
layers and a timeline of its own, just like with the **button** and **movie clip
symbols** we looked at earlier. You can use this to create an animated symbol.
Why would you want to do that?

**Expanded Version of an Animated Graphic Symbol Containing a
Frame-by-Frame Animation**

1 In this example I have drawn a frame-by-frame animation of a bird in
flight, which is contained within an animated symbol.

The Frames Within the Symbol

2 The flying eagle animation in this symbol lasts for 16 frames.

▼ Timeline

		1	5	10	15	20	25	30	35
🦅 flying eagle									

**The Flying Eagle Layer Lasts for 32 Frames.
Therefore, the Animation will Loop Twice**

3 When placed on the timeline the flying eagle animated symbol will loop after 16 frames. In order to see the animated loop, you will need to insert some frames onto the timeline.

4 Just like a static graphic symbol, the **animated graphic symbol** can be made to follow a **motion path**. You can also

The Animated Graphic Symbol Following a Motion Path

apply all of the other types of animated changes that work with motion tweening. Your animated symbol can also **move, resize, rotate, change color**, or **transparency** and be **motion tweened**.

5 In other words, you can use animated graphic symbols to **animate pieces of animation** with **motion tweening**.

Onion Skin Outlines Shows how the Animated Symbol is Following the Motion Path

6 When you use animated graphic symbols, you can choose which frame you want the looped piece of animation to start on. This is done in the **Properties Inspector.**

7 Click on your animated graphic symbol to select it and from the **options for graphics** in the **Properties Inspector** you will be able to

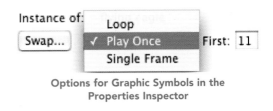

Options for Graphic Symbols in the Properties Inspector

choose whether you want your piece of animation to **loop, play once** or just show a **single frame**. You can also add a number into the **First:** box, which specifies the first frame that will be shown.

8 This means that you can have several copies of the same piece of animation all playing at the same time, but all starting on a different frame. Very handy for a flock of birds!

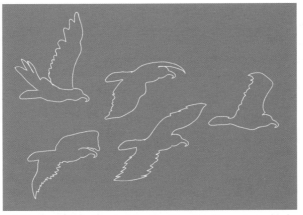

A Flock of Birds Created by Starting the Same Animated Graphic Symbol Loops on Different Frames

Creating a Looped Background

Another use for animated graphic symbols is to create a looped background. For example, if you had a character walking on the spot, you might want to

have a looped background of scenery going past in the background – adding to the illusion of the character walking through space.

A tip for creating a perfect loop is to start by making your first frame exactly the same as your last frame. Create the scenery moving and then returning to the initial frame.

If you created the loop like this, there would be a slight jump when it plays back as the first and last frames are the same. So, to get round this, create a keyframe on the second last frame and then delete the last frame.

Your loop should now play endlessly without you being able to see the join.

Copying and Pasting Frames

At times you may create a complicated animation on the Stage and wish that you had created it all within one animated symbol. Perhaps you want to animate the scale of the whole scene so that it looks as if you are zooming in with a camera.

It is possible to take animation from the Stage and convert it all into one animated graphic symbol, which you can then motion tween as a whole. Here's how:

1 Click on the name of the first layer you want to select. Clicking on the layer name selects all of the keyframes and frames on that layer.

Four Layers and all Their Frames are Selected

2 Then hold down the **SHIFT** key and click on the names of all the other layers that you want to select. By now all the frames and keyframes on all of the layers you want will be selected.

3 Next choose **Edit > Timeline > Copy Frames – CTRL/CMND + ALT + C** (or if you are feeling brave **Edit > Timeline > Cut Frames – CTRL/CMND + ALT + X**).

4 Then create a new graphic symbol – **Insert** > **New Symbol**.

5 Click into frame 1 of layer 1 in your new symbol and then **Edit** > **Timeline** > **Paste Frames** – **CTRL/CMND + ALT + V**. All your layers and frames will now have been pasted into the new symbol and your layers will even retain the names you gave them.

6 This new animated graphic symbol containing all of your animation will be in the **Library**. Go back to your main scene, delete the original layers you copied, make a new, fresh layer and then drag in the new animated symbol that you created.

Symbols Within Symbols

Just as you can animate a graphic symbol using its own timeline and layers, so you also bring other graphic symbols into a graphic symbol. Here is an example of a whole character built with graphic symbols that are contained within one whole graphic symbol.

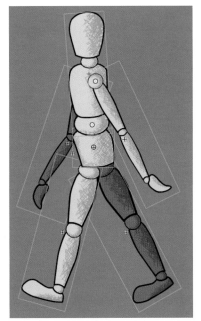

1 This figure is jointed like a puppet. It uses very few basic symbols. The ankle, knee, shoulder, elbow, hip joints, and waist are all made from the same basic graphic symbol. All the parts of the limbs also use the same graphic symbol.

2 The character has been separated into different symbols according to how it will move and each of

The Various Symbols Making up the Whole Character, Which is Itself a Symbol

these symbols is on a separate layer so that they can be animated individually.

3 The individual symbols have been nested together in a hierarchy of symbols all contained within one symbol. The whole character has been created within one symbol so that it can be motion tweened as a whole.

4 If you group elements of the body together in sections, then you can manipulate these whole sections together as one piece and still have the option to move the individual symbols. However, grouping elements together that are on **different layers** through **Modify > Group** is **not** very successful in Flash.

5 A more effective way to achieve this is by grouping elements together by placing several body parts into a new combined graphic symbol. This is done by selecting symbols on the stage and **Modify > Convert to Symbol**.

6 So for example, you could select the **foot** and the **calf** symbols and convert them into a new composite graphic symbol called **lower leg**.

7 The following flow charts show how the graphic symbols making up the **leg** and **arm** were built into a hierarchy in this example.

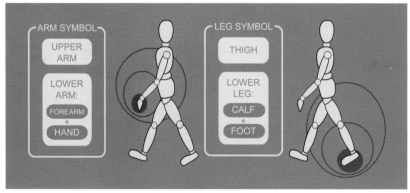

The Arm and Leg Symbols

8 So even though the leg contains several parts, all of these parts can be moved together as one.

Altering Symbol Center Points

9 Our skeletal structure works by rotation – our body parts rotate around our joints, so we need to make sure that each element that we want to animate can also be rotated around the correct joints.

Changing the Center of Rotation for the Leg and Arm Symbols

10 Each of the **leg** and **arm** composite symbols has its center point changed to the center of the nearest joint. This was done with the **Free Transform** tool. So the center point of the leg symbol has been moved to the hip point and the center point of the arm has been moved to the shoulder.

11 Now if the **leg** is rotated and it will move around the **hip joint** and the **arm** will rotate around the **shoulder joint**.

12 If you double click on the **leg** symbol, you will now have access to the **thigh** and **lower leg symbols**. The center point of the **lower leg symbol** was changed to the **knee joint** with the **Free Transform** tool.

Changing the Center of Rotation to the Knee and the Elbow

13 Each time you double click on a symbol, you go one level deeper into the hierarchy that you have made and you can make adjustments. Your character can now be manipulated like a jointed puppet.

Using Scenes

Each Flash project that you work on can be divided into **Scenes**. This can be very useful if you are working on a story and you want the freedom to easily be able to re-order the different sequences.

The **Scene panel** can be accessed from the **Window** menu under **Design panels**.

Just like layers, **Scenes** can be dragged up and down to change their order. Scenes at the top of the list are shown first and those at the bottom are shown last.

To re-name a Scene, double click on its name.

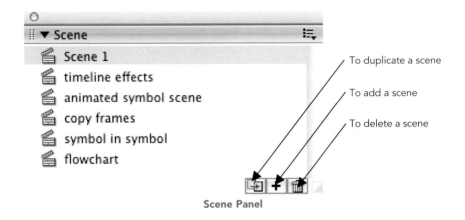

Scene Panel

Character Design Tips

What kind of personality does your character have? How it moves will give a lot of clues about your character. Think about the joints and the mechanics of the movement – where does a figure bend, how do the pieces fit together and how do they move?

Create model sheets for your characters showing them from the side, front and three quarters views and with different expressions.

Use this as the starting point for a library of parts for your character – mouth shapes, costume changes, hairstyles etc.

It can be hard to imagine what your character might look like in motion or from different angles so:

- buy toys or models of a similar shape,
- sculpt plasticine or clay models,
- use mirrors to look at yourself from different angles,
- video your friends,
- make quick sketches of passers by out in public.

Creating Sounds to Bring into Flash

There are lots of places on the web to download free sound files – legally! The Resources appendix at the end of this book contains links to some such sites. If you are a music whiz kid, on the other hand, you may want to compose your own soundtracks using software such as Adobe Audition or Cubase.

You cannot import a music track into Flash from an audio CD. It is not in the correct format to be used in Flash and if you do not have permission this would be infringing copyright.

It can be fun to record your own sounds. These could be **foley effects** – sounds effects you make yourself – such as banging two halves of a coconut together to make the sound of horses hooves – or **voice** recording.

Capturing sound on a Mac or a PC depends on your computer having a soundcard installed. Most recent machines should have one.

Sound Recording
Utility on a PC

On a PC there are different brands of soundcard and each one has its own generic sound program. The Windows operating system also comes with a **Sound Recorder**, which you should be able to find somewhere in **Start > Programs > Accessories**. When you have located a sound capture program, all that remains is to plug a microphone into your sound card and sing your heart out! Remember to make sure that the levels indicator doesn't go into the red.

On a Mac, if you don't have a specialized sound program, you can use **iMovie** to record sounds and then **export** them as audio only QuickTime movies.

The sound tools in Flash are quite limited, so it is best to create the sound file exactly as you want to use it in your audio software before you bring it into Flash.

In order to bring sounds into Flash, they must have been saved as one of the following sound file formats:

- **WAV** (Windows only)
- **AIFF** (Mac only)
- **MP3** (both)

If you have QuickTime 4 or later loaded onto your computer, you will also be able to use **WAV**s on a Mac, **AIFF**s on a PC and audio only **QuickTime** movies. See the Flash Help files for information on more specialized sound formats.

Some Fundamentals of Digital Audio

WAVs, **AIFF**s, **MP3**s and audio only **QuickTime** movies are complete representations of the sound information. They are a bit like **bitmaps**.

MIDI (musical instrument digital interface) files are also used by musicians to transmit sound information. They are not, however, a complete representation of a sound, but a series of mathematical note instructions – a bit like a **vector**. Flash cannot read these files – they need a sequencer to be played back.

When you record a sound on your computer you are actually converting a natural sound vibration in the shape of a wave into digital information. This is done by taking samples of the wave at regular intervals.

The **frequency** of samples per second taken is measured in **kHz**. The higher this number is the better the quality of the sound will be. You should be able to choose one of these rates in all sound editing programs:

5 kHz	Roughly the quality of a phone call
11 kHz	Average TV quality (without Nicam stereo and surround sound)
22 kHz	FM radio station with good reception
44 kHz	CD ROM quality

The other variable with sound recording is the **bit rate**. This is the amount of storage space given to each of the samples. Try to use as high a bit rate as your target file size will allow for, as this setting has a dramatic effect on sound quality.

Importing Sounds

To import a sound:

1 Choose **File** > **Import** > **Import to Library** and select the file you want to import.

Drag from here onto the Stage

A Mono Sound File in the Library

Click here to hear the sound
A Stereo Sound File in the Library

2 Your sound file will now be in the Library along with any symbols you have created or bitmaps you have imported. Notice the **play** button in the Library thumbnail preview window.

Once you have some sound files in your Library, you can add them to your movie in two different ways:

1 Just as you would with a bitmap or symbol, make a new layer for the sound to go on and then drag the sound file from the **Library** thumbnail preview window onto the **Stage**.

Choosing a Sound File from the Properties Inspector

2 The other method is to click the first frame of a new layer and then select your chosen sound from the drop down box next to **Sound:** in the **Properties Inspector**.

3 It is best practice to make sure that each sound that you use is on its own individual layer.

4 Next you need to add frames for the whole duration of the sound. How do you know how many frames to add?

Sound Information in the Properties Inspector

5 When the first frame of the sound layer is clicked on, information about the sound file is shown in the Properties Inspector. This information shows the quality, length and file size of your sound. In the example above, the sound file is 7.2 seconds long.

6 To find out how many frames to add to your sound layer to be able to hear it all, use the following formula:

LENGTH OF SOUND × FRAME RATE

7 So in this example, if my project's frame rate is 25 frames per second, and the sound file is 7.2 seconds long – 7.2 × 25 = 180 – so I will need 180 frames in order to be able to hear all of the sound.

Audio Layers on the Timeline

8 Once you have all of the frames you need on the Timeline, you will be able to see the shape of the audio waveform.

Streaming vs. Event Sounds

The sound information in the Properties Inspector, that you see whenever you have clicked on a frame of a sound layer, also contains an option called **Synch**.

Audio Synch Options in the Properties Inspector

The **Synch** option that you choose depends on what you want to do with a sound. There are four options:

1 **Stream** is used for animation and straightforward playback from the Timeline. If **Stream** is selected, the sound will be 'scrubable' in other words, you can drag the playhead and hear a rough preview.

2 A **streaming** sound is synched to the Timeline – in other words, it will only last for the amount of frames that you have given it and will play along with any animation. If your animation is on the web and cannot be played back at full quality, the animation will drop frames to stay in synch with the audio.

3 **Streaming** sounds can start playing before they are completely downloaded.

4 **Event** sounds are played independently to the Timeline (in the same way that a Movie Clip symbol is independent of the Timeline). They need to be **triggered** by an **Event**, for example, a **Button**.

5 **Event** sounds must be downloaded completely before they will play back. They must be explicitly stopped by a **Button, Behavior** or **Action** or they will play right to the bitter end.

6 If the **event** is triggered several times, for example, if a user pushes a button repeatedly, several instances of the sound will play at the same time.

7 **Start** is similar to **Event**, but will only play one instance of a sound if the event is triggered several times.

8 **Stop** will stop the sound playing. Use **Stop** on a new keyframe in your sound layer to make the sound stop.

As well as choosing what you want to use the sound for, you can also choose how many times you want it to play back in the Properties Inspector.

Choose **Repeat** and add a number in the box to determine how many times the sound will be repeated.

Repeating or Looping Sounds in the Properties Inspector

Choosing **Loop** will loop the sound endlessly.

Do not use **Loop** for **streaming** sounds with web animation, because it will add to the overall file size. It is preferable to specify exactly how many times you want the piece of audio to be repeated.

Editing Sounds in Flash

Flash is not a sound editing program, but there is a limited amount of effects and editing that can be done to sounds.

The following **Effects** can be applied to a sound from the Properties Inspector. When an effect is selected, you can click on **Edit** to see more information about it and to customize it.

Sound Effects in the Properties Inspector

- **None** – this is used to remove an effect that was previously applied.
- **Left Channel/Right Channel** – plays the sound only in that channel.

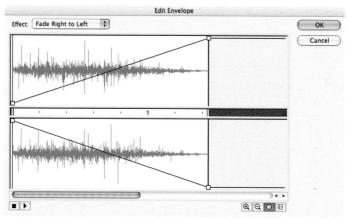

The Fade Right to Left Effect

- **Fade Left to Right/Fade Right to Left** – creates a 'panning' effect by shifting the sound from one channel to another.
- **Fade In/Fade Out** – the sound starts off quiet before increasing to full volume or the reverse.
- **Custom** – use this to create your own effect. It will open the **Edit** window.

Drag these to trim the 'in' and 'out' points of the sound

Click on this line to add a handle

Drag the handles up and
down to change the levels

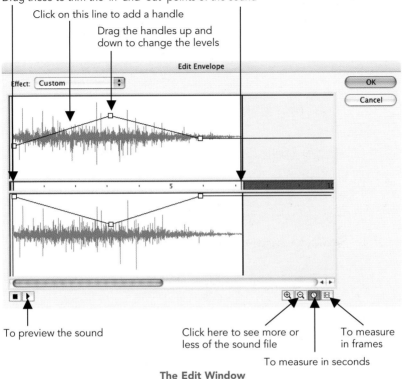

To preview the sound

Click here to see more or
less of the sound file

To measure in seconds

To measure
in frames

The Edit Window

Attach a Sound to a Button

1 Import the required files into your Library.

2 Create a button as before: **Insert** > **New Symbol** > **Button**.

3 Make a new layer called **sound** and **insert blank keyframes** in the **Up** and **Over** states.

4 If you want your button to make a sound when the cursor **is over it**, **insert** a **keyframe** in the **Over** frame.

5 Select this keyframe and choose the sound file you want to use from the **Sound:** drop down list in the Properties Inspector.

6 Choose **Start** as your **Sync** type.

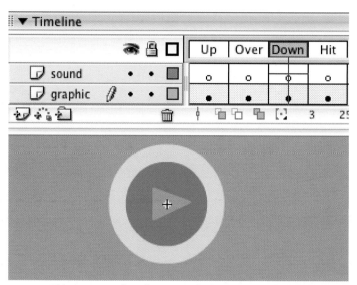

This Button will Make a Sound when it is Clicked on

7 If you want your button to make a sound when it is **clicked on, insert** a **keyframe** in the **Down** frame and repeat stages 5 and 6 above.

8 Go back to your main scene and drag a copy of this button onto the Stage. Turn on **Control > Enable Simple Buttons** and drive your neighbors crazy by testing it out.

Adding Comments to Frames

If you are working with voice tracks, it can be useful to add comments as you are going along to remind you of what is said.

This can be especially valuable if you are animating a character's mouth shapes and facial expressions to match a piece of dialogue. The **lip-synching** process depends on breaking speech down into sounds. Here's how to comment your voiceover:

1 Create a layer for your frame comments. **Insert** a **blank keyframe** where you want the first comment to be. Select this keyframe.

2 Type the letters of the sound into the Properties Inspector.

Add a Frame Label in the
Properties Inspector

Choose Comment as the
Label Type

3 Choose **Type** > **Comment**. This ensures that these comments will not be exported with your final movie and will keep your file size down.

The Speech is Broken down into Sounds

Warning about File Sizes

Sound files can add enormously to the size of your project. If you are creating work for the Internet you will need to get those audio files as small as possible.

Tips for lowering audio file sizes:

1 set in and out points for silent areas;

2 loop small pieces of sound for background music;

3 try to use the same sound with different effects;

4 stereo files are twice the size of mono files – do you really need stereo?

Chapter 14, Putting Flash on the Web includes information about compressing audio and exporting movies with audio files.

What is Digital Video?

The term **digital video** refers to any format that stores digital audio-visual information. So this could be a QuickTime movie or an AVI file, it could be on a DVD, zip disk, CD, mini DV tape or a streaming movie on the Internet.

As the audio-visual information is stored digitally, copies can be made without a loss in quality and it is much easier to edit and manipulate than with traditional processes.

If you own a digital video camera then you will be working with both **digital video** and **DV**.

The term **DV** does not mean the same as **digital video. DV** is an actual type of video format. Other types of video format include **VHS** and **BETA**.

Choosing Cameras at IBC, Amsterdam

With the **DV** format, a digital camera is used to **convert** audio-visual information in front of the camera into **digital** information. This process takes place **inside the camera.** It has a **fixed size,** uses **DV tape** and the **DV compression type.**

How do you Bring it into Your Computer?

You cannot use Flash to take video directly from a tape. You will need to use a video editing program like Adobe Premiere, iMovie or Final Cut Pro for this.

In order to bring video into your computer, it must first be converted into a digital form that your computer will understand.

There are several ways to do this:

1 Use a **digital** video camera and input/output the video via an **IEEE 1394/Firewire cable** connected from the camera to an **IEEE 1394/Firewire port** on the computer.

2 Use a traditional **analogue** camera or video deck and connect this to a **video capture card** installed inside your computer. This will convert the information from analogue to digital.

3 Create moving images **in the computer** with an animation program.

Using Video in Flash

Video can be imported as:

- **Macromedia Flash Video (FLV)**

Flash will also allow you to import the following moving image file formats if you are on a Mac or PC with QuickTime 4 or later installed:

- **AVI**
- **MPEG** (will not import audio)
- **QuickTime**

If you are on a PC and have DirectX 7 or later installed, you can also import the following formats:

- **AVI**
- **MPEG**
- **Windows Media**

Video files are imported using **Sorenson Spark compression.** This highly effective type of compression or **CODEC** enables video clips, which would normally have huge file sizes, to be embedded in Flash movies with impressive reductions in file sizes.

To import video, follow these steps.

1 Make sure you have a new layer for the video to go on and then choose **File > Import > Import to Stage**. A Video Import 'wizard' will open to guide you through the import process.

2 If your video is in the form of a QuickTime, then you will have the added option of embedding or linking the video.

3 Then choose **Import Entire Video > Next**.

Choose which Type of Connection you Think that Your User will Have

Or Create Your Own

Video Import

QuickTime Editing Encoding (Compression Settings)

○ Bandwidth: — 0
 0 750
⦿ Quality: — 100
 0 100
 Keyframes: — 0
 0 150
☐ High quality keyframes
☐ Quick compress
☑ Synchronize to Macromedia Flash document frame rate
 Number of video frames to encode per
 number of Macromedia Flash frames 1:1 ⇕

00:00:00,000

Alter the Settings to Suit Your Purpose

Video Import

QuickTime Editing Encoding (Save Settings)

Please enter a name and description for the new preference:

Name: Best quality

Description: Quality at 100%

Name Your Settings and add a Description

Video Import

56 kbps modem
Corporate LAN 150 kbps
DSL/Cable 256 kbps
DSL/Cable 512 kbps
DSL/Cable 786 kbps
✓ Best quality

Create new profile...

It will now be Available in the Drop Down List of Presets

4 Flash will automatically add the number of frames needed to insert all of your video onto the Timeline.

5 Now the video is imported it can be manipulated like any other object – resized, rotated, skewed, moved and masked.

6 It can be used as a background layer with graphics and drawings on the layers above.

7 In the **Behavior** panel, you will also find **Embedded Video Behaviors** that you can combine with **buttons** to create your own video controller.

8 Dragging the playhead allows you to preview the visuals, but in order to hear the audio you will need to select **Control** > **Test Movie**.

Rotoscoping

Or how to cheat at animation!

Rotoscoping is the process of drawing on film. It is named after the Rotoscope – a machine used by early animators such as Disney and the Fleischer Brothers to trace film of actors moving.

Rotoscoping Video in Flash

You can use the same technique in Flash. Video a scene or character and use this as reference for your animated drawings. Trace over on a layer above adding keyframes on every one or two frames. Delete the video at the end and you will be left with accurate drawings of movement.

You can even rotoscope your own Flash files:

1 To avoid a conventional motion tweened 'look', first create a motion tweened animation for speed and guidance.

2 Then on a new layer trace over each frame roughly, deliberately varying the placement of the line.

3 You will then get a style known in animation as **'boiling'** where the outlines seem to shimmer and shake.

Preparing for Video Output

Although Flash is increasingly being used to create low-budget animation for television and commercials, it isn't actually designed to work with full size broadcast video. It specializes in video for the web. However, if you are aware of the technical issues involved, you can get around this.

There may seem to be many complicated technical issues to consider when outputting from Flash for video, but if you want good quality results you must be aware of them right from the start.

You cannot use Flash to put animation directly onto video tape. To do this you will need to use a video editing program like Adobe Premiere, iMovie or Final Cut Pro. The animation must be exported from Flash with the correct settings to enable you to take it into a video editing program and then export it onto tape.

Frame Rate and Frame Size

First of all, you must use a standard frame rate and size according to the system of video used in the part of the world in which you live.

This will be 25 frames per second if you are using the **PAL** video system. This is the type of video used in the UK, much of Europe, Africa and the Middle East, Australia, New Zealand, China, and India.

The frame size for **PAL** is 768 × 576 (square) pixels.

If you live in the USA, Canada, South America, the Caribbean, Japan, Korea, or Taiwan, however, you will be using the **NTSC** video system. This has a frame rate of 30 frames per second. (The figure is actually 29.97 but you can use a video editing program to convert this for you.)

The frame size for **NTSC** is 640 × 480 (square) pixels.

Documents Settings for PAL/SECAM Video

Documents Settings for NTSC Video

There is also a third video system called **SECAM**, which also uses 25 frames per second and is used in France, Eastern Europe, and some of Africa and the Middle East. It is similar to PAL, but uses a different color management system.

The frame size for **SECAM** is 768 × 576 (square) pixels.

Flash is not always able to play back 100% accurately from the Timeline with the full frame rate. If want to export your work to video and your timing is important to you, export test movies regularly and play them in your editing software.

Pixel Aspect Ratio

In Chapter 5, **Importing Images,** we looked at bitmap images and how they are made up of tiny little square pixels.

Digital video is a type of bitmap. However, it doesn't use square pixels, but rectangular or **non-square pixels**.

Flash cannot create files with non-square pixels – it works with square pixels.

So make your Flash movies with the square pixel frame sizes given above and use a video editing program to convert them to non-square pixels for you afterwards.

If you do not use the square pixel frame sizes given above, your images may appear squashed or stretched when viewed on video.

Frames vs. Fields

When you create animation in Flash, you can look at all of the individual frames that go into making it up.

Although video is commonly thought of in terms of frames, each **frame** of footage shot on video is actually divided into two **fields**.

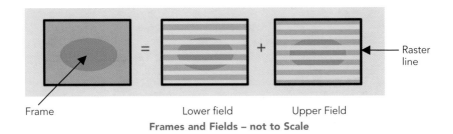

Frame Lower field Upper Field Raster line

Frames and Fields – not to Scale

These two **fields** are **interlaced** and when viewed one after the other, they form one whole frame. The interlaced lines are called **raster lines**.

So although we think of **PAL** or **SECAM** video in terms of **25 frames per second** it is more accurate to say it is **50 fields per second**.

Similarly, although we think of **NTSC** video in terms of **30 frames per second** it is more accurate to say it is **60 fields per second**.

Flash cannot create animation in fields per second – only frames per second.

Using a video editing program will convert animation created in Flash into fields per second for you.

Why bother about fields if your editing program will create them for you?

When you put your Flash animation on to video and the frames are converted into fields, **hairline** or **one pixel lines** and **thin, small fonts** may appear to **flicker**.

So if you want your Flash animation to end up on video, make your lines no smaller than two pixels and use bold, chunky fonts, preferably 18 pts and above.

Broadcast Safe Colors

Not only does video have its own specific frame rate, frame size, pixel aspect ratio and field issues, but it also has its own **color gamut**! A **color gamut** is a range of colors that a medium can represent. You can create many more colors on a computer than a video tape can record.

Luminance Chrominance Saturation
Color Components

There are three components of color on video:

- **luminance** – brightness or image intensity or tonal value;

- **chrominance** – or hue – actual color;

- **saturation** – color intensity, for example, full red vs. pink.

If one of these levels is too intense or **illegal,** then you will get a smearing in the image when it is played back from video that is also known as **video bleed**.

There is no way to check for video bleed in Flash. This needs to be done in a video editing program like Adobe Premiere or Final Cut Pro or a compositing program like Adobe After Effects.

The following tips will help you to avoid video bleed:

- Don't use very bright colors. De-saturate bright reds and blues by 20–30%.

- White text on black (and vice versa) can turn out badly – use pale cream or gray instead of white.

- Put test versions onto video regularly and check them out on a properly calibrated monitor.

- Use color correction filters in your editing software as a last resort.

Over scan

There is one final issue to consider when creating Flash movies for output to video and that is **over scan**.

Television sets have a slight curvature at the very edge. There is no standardization! Different models have different amounts.

What does this have to do with Flash?

If you don't take this into consideration part of your image may be unexpectedly cropped off at the sides.

Keep in mind the **safe title** and **safe action** zones indicated in the diagram below.

Safe Title and Action Zones

Keep all of your important action within the **safe action** zone and all of your text titling within the **safe title** zone.

Chapter 15, **Cross-media Publishing,** covers the process of exporting from Flash to different delivery media, including video.

CHAPTER 13
DESIGNING FOR CROSS-MEDIA

Our 21st Century world is full of information. In cities you can find information on every corner with interactive street kiosks, animated billboards, Internet cafes, TVs in homes and shops windows, people with arrays of small, portable devices such as Pocket PCs or PDAs, mobile phones, and VCD players.

You can create content for all of these different media and devices with Macromedia Flash 2004.

Vector graphics programs, like Flash, are resolution independent and ideal to use for exporting to all different types of media. The same Flash file can be exported for a mobile phone movie or a billboard size poster campaign without loss of quality.

It is seductive to use exactly the same design across all of these different output devices, however each different device that you can create Flash content for has its own set of limitations. Each different type of device has a different screen size and resolution, different bandwidth and frame rate. Some of them also use different color models.

In addition, a design composition that works well on a billboard poster may be impossible to see in any detail on a small PDA handset.

All of this needs to be considered when you are starting your project, because your output will influence your input. Be prepared to make subtle changes to your original design.

It is also important to consider exactly whom you want to communicate with. Define the goals of your project – whom are you aiming it at and why would they be interested? Look at a range of examples of work from competitors and think about its pros and cons.

So, your first step in planning a Flash project is thinking – 'where will I use this?' and 'who do I want to see this?' In other words who is your **target audience** and what will be your **delivery medium**.

Planning a Web Site

Let us focus on designing web sites, because there is not enough space in a little Easy Guide to consider all the possible delivery media in depth. Many of these considerations can also be applied to other media.

As a starting point in the design and planning process, think about the following questions:

- What kind of computers do you think that the people who will look at your web site will have – lowest common denominator or latest high tech, Mac, PC, a mixture?

- Do you think they will have large monitors, small laptop screens or medium-sized monitors?

- Do you think they will have the latest versions of a browser such as Internet Explorer or Netscape loaded on their machines as well as all the latest multimedia plug-ins?

- Do you think they'll be looking at your site at work with a fast broadband connection or at home with a slow domestic modem?

- Could they be 'looking' at your site with audio: using screen reading software?

- Could they be browsing from non-computers such as WAP phones, PDAs, interactive TV or Sega's Dreamcast?

All of these questions effect the overall dimensions of your project in pixels as well as the complexity and size of your files.

When you have made some decisions about your web site, you can start to plan your content. **What** are all the pieces of information that you want to include? **How** will they fit together? Draw a **flow chart** to help you. A **flow chart** is a good way to work out on paper the connections between the different pieces of information that you have.

It is also very important to plan **where** to put all the different files that you create for your web site and how you will **name** them. As you are working keep a note of the following:

- Lists of different files or assets – **what are** all of the files that make up your web site including tests, research, scans and sources files?

- Naming conventions – what did you **name** them?

- Storage location for all documents belonging to your web site – **where** did you put them?

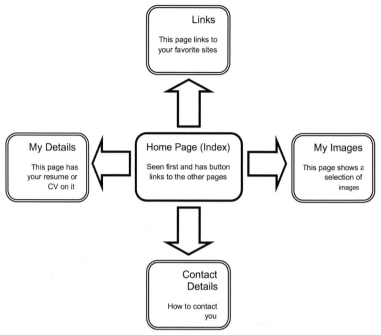

A Flow Chart Plan for an Online Portfolio

Information Architecture

When you are designing a web site, what you are doing is designing a way for the user to navigate through a mass of information. You should try to make this journey as straightforward as possible. When you have been working on a project for some time, it may seem obvious to you how to find your way around it. Other people who have not seen your project before may not find it so easy. The 'buzz' word right now is **'usability'**. How useable is your site? Try to test your site on friends and colleagues before you upload it to the web.

Try not to use the cliches of conventional web design – try new ideas. Be inspired by maps, journeys, roads, cities, buildings, stories – all of these involve moving from one piece of information to another.

Successful design is a mixture of coherent and logical structure and visual organization. Information should be structured so that it is clear

and easily accessible. Use the following tips to make your site easy to navigate:

- try to be no more than two clicks away from either the home page or a site plan on any page;

- have clear links and back buttons on each page;

- build in several alternative routes to information;

- design for speed – use small files for a fast download time;

- maintain a visual identity with a consistency of color, design, icons and navigation throughout the site – people get used to a system;

- the form of your site should follow its function – superfluous graphics and animation can increase your download time without giving your user the information that they came to your site to find.

Finally, think of reasons why people might want to return to your site again in the future. This is also known as *sticky content*'. Some examples of this could be:

- games;

- up to date information;

- entertaining animation;

- extensive links;

- competitions;

- web cam;

- chat rooms;

- send a greetings card;

- forum;

- message board.

Design for the Web

There are several approaches to using Flash for the web. The entire web site could be created in Flash and put on one single host HTML page, perhaps loading external files to save on file size. On the other hand, you could create

a conventional HTML hyperlinked web site and add Flash elements to individual pages as required.

Size

There are two types of size to consider when designing for the web:

1 **Web page dimensions** – measured in pixels;

2 **File sizes** – measured in kilobytes.

The shape of the web page that you will be designing is in landscape format and important information should be at the top of page or **'above the fold'**. People are used to accessing information quickly and may find it irritating to have to scroll to the right or downwards in order to see the whole site.

The browser program itself takes up space with menus, toolbars and scrollbars. Safe recommendations for web page sizes, which will fit the following monitor resolutions, are:

Screen Dimensions	Width	Height
640 × 480	600	300
800 × 600	760	420
1024 × 768	955	600

These dimensions do not take into consideration scroll bars, which will take up extra space.

The other aspect of size to consider is **file size**. Different web users have different bandwidths to contend with. Not all of your target audience may have access to a fast ISDN or broadband line.

Web access from mobile phones is common in Japan and South Korea, but not in the USA or most European countries where users prefer to surf from their computers.

A statistic on **http://www.dreamink.com** states that 64% of people accessing the Internet from home are doing so with domestic modems and only 36% have broadband.

However, the situation is reversed with people surfing the web at work – 69% of them are using broadband with only 31% of work users having narrowband.

It is often said that sites, which take more than 20 seconds to load, will lose 50% of their visitors.

Web users do, indeed, have short attention spans. Statistics from **http://www.nielsen-netratings.com** show that the worldwide average duration of a web page viewed at home is 48 seconds and a few seconds more for viewing at work. This includes both **loading** and **reading** time.

An average domestic modem of **56 kbps** is measured in **kilobits** per second. If you take into consideration the fact that images are measured in **kilobytes** (a slightly different unit of measure) and that connection speeds are slower than expected because of the traffic of other users on the web, the actual speed of transmission translates to more like **4 kilobytes per second**.

So for a page to load in **20 seconds** it should be **no bigger than 80 kilobytes**, preferably **less**. This means your entire swf Flash file should be no more than 80 kilobytes. However, if you expect your audience to be mainly viewing your site from work, you could afford to make it slightly larger.

A typical **web banner** size is 468 × 60 pixels and around 15 kilobytes or less. The entire animated cycle should stay within a 3-second time limit and it should be possible to read all of the text within 2-seconds. Keep the frame rate between **10 and 15** frames per second. This is a good frame rate range to use in general for web animation.

Color

The use of color in web design is always going to be **approximate**. The display of color across different platforms and monitors can be unpredictable. Images can appear darker on a PC monitor and every user may have their monitor calibrated in a slightly different way.

Some people are using monitors that can display millions of colors while others can only display 256. Mac and PCs show two slightly different sets of 256 colors and only 216 overlap. These 216 colors are known as a **web safe palette** and are the only ones that can be guaranteed across both platforms.

Web Safe Colors in Color Swatch Panel

Colors on the web are described using **hexadecimal code** – a combination of six letters and numbers, for example white is #FFFFFF. Flash allows you to work with web safe colors. You can enter hexadecimal code directly in the **Color Mixer** panel or choose from the **Web 216** color palette in the **Color Swatches** panel options.

If you are designing for a corporate client who want to maintain their brand identity through the use of certain colors or if you yourself want to restrict the number of colors that you use, you can create your own customized **color palette**. This is done in the **Color Swatches** panel:

1 To ensure that the colors you use are all web safe, load the **web safe palette** in the Color Swatches panel by choosing **Color Swatches Options > Web 216**.

2 Then delete the colors that you **don't** want to use by selecting them and then **Delete Swatch** from the **Color Swatches Options** menu.

Or

3 Select **Color Swatches Options > Clear Colors** to remove all of the colors in the **Color Swatches** panel apart from black and white.

4 Next mix up the colors that you **do** want to use in the **Color Mixer** panel and choose **Color Mixer Options** > **Add Swatch**. This will add the new colors to the **Color Swatches** panel.

5 To export your new color palette, select **Color Swatches Options** > **Save Colors . . .** Name your color palette and save it as a **CLR (Flash Color Set)** file.

6 You can now import this color palette into any Flash project by choosing **Color Swatches Options** > **Replace Colors**. This will replace the contents of the **Color Swatches** panel.

7 Alternatively, **Color Swatches Options** > **Add Colors** will add your custom color palette to the contents of the **Color Swatches** panel.

Typography

There are pros and cons to using the **HTML** of the host web page to display text as opposed to creating all of the text in **Flash**.

Standard **HTML** text on a web page will load very fast, but the text formatting possibilities available are not as extensive as that available in Flash. Also, positioning and formatting are imprecise. Finally, unless you have turned the text into a graphic, fonts will appear larger on a PC rather than a Mac. It is important to test your designs on both platforms.

Creating text in **Flash** gives you much more precision in positioning and formatting. However, the text contained within a Flash movie will not be seen until the whole movie has loaded.

Usability

Flash has huge potential for the creation of fantastic animation and interactive games, however if these are badly designed you can end up with a site that alienates the user.

There is a lot of debate in the world of web design about the gratuitous use of Flash elements, which lack integration with the content and show the talents of the designer rather than enhancing the communication of ideas.

Avoid this! Make sure your intro movie has a **skip** button for users who have visited your site before. Keep your graphics and animation lean, mean, and relevant. Looping movies can also be seen by some as annoying on the web – think before you loop!

Another issue that can arise with the usability of Flash web sites is **disability access**. A growing number of visually impaired web surfers are using audio browsers which 'speak' the contents of the screen or text only browsers. Legislation is being introduced in many countries around the world for the adoption of accessibility standards. For example, in the United States, Section 508 prohibits federal agencies from commissioning web sites, which are not accessible to people with disabilities.

The standards used are from the Worldwide Web Consortium and you can find more information about them and the whole issue of web content accessibility at **http://www.w3.org/WAI**.

Flash MX 2004 contains a new **accessibility** panel, which allows you to add accessibility features to your site. This is discussed in the next chapter. Other general design tips for creating sites, which are easier for partially sighted or visually impaired viewers to use are:

- Use sans serif fonts – they can be clearer to read.
- Make sure there is a clear contrast between the background and text colors.
- Use a simple layout.
- Have a text only alternative for your site.

Planning for Animation

If you are creating an animation in Flash, it will save you time to plan it all out beforehand with a **storyboard**. This could be quite roughly done if it is just for your own use – a few scribbles on the back of an envelope. On the other hand, you may spend some time getting your storyboard to look good if you want to sell your idea to someone else. Spending time on the planning stage will save you time in the long run.

If you are intending to create an interactive story or game with several possible plot twists, then you could plan this out with a combination of a flow chart and a storyboard. Pinning index cards or sticky 'post-it' notes onto a wall so that you can re-arrange them can be a useful process.

It is also good practice to plan your characters. Consider how they will look from different angles and with different expressions. Sketch these all out on one sheet. This is called a **model** sheet in traditional animation.

The storyboard is useful for planning a sequence of events and can be used to create an **animatic**, which allows you to test out the timing of your animation. Here's how:

1 Scan all of your storyboard drawings in low resolution – to keep the file sizes down.

2 Check that your frame rate and document sizes are correct for your delivery medium – web, video etc.

An Example of a Quick Storyboard

3 Put each drawing on a separate keyframe and give it extra frames to last for the time that you think that sequence should take.

4 Preview to see if your timing works and your story makes sense. Show to friends and colleagues and ask their opinion.

CHAPTER 14
PUTTING FLASH
ON THE WEB

Now that you have designed and produced a slick, all-singing, all-dancing Flash web site, what are the practicalities of putting it on the web?

Accessibility

One of the new features of Flash MX 2004 is the **Accessibility** panel, which makes it straightforward to add accessibility features to your Flash projects that will make them easier to use with audio browsers.

Remember that, in many cases, accessibility is a legal requirement and the responsibility for this lies with the designer/developer.

1 To open this panel, go to **Window > Other Panels > Accessibility**.

2 When the background of the Stage is clicked on and the **Document** properties are showing in the Properties Inspector, you will see the following settings in the **Accessibility** panel:

3 **Make Movie Accessible** is on by default. This allows accessibility information

> ▼ Accessibility
>
> ☑ Make Movie Accessible
> ☑ Make child objects accessible
> ☐ Auto label
>
> Name: Portfolio site
>
> Description: This page contains button links to images and contact details.

The Accessibility Panel

about your whole movie to be passed to a screen reader program by Flash Player. It will allow the software to 'read' out loud the names and descriptions you have given.

4 Add a **name** and a **description** summarizing all the elements on screen that do not contain text. It will help users who are browsing with a screen reader if you include information about the layout and navigation controls.

5 **Flash Player** automatically provides a name for **static text** and **dynamic text**, which is actually the same as the contents of the text, so text does not need to be labeled through the **Accessibility** panel.

6 Make Child Objects Accessible is used for information nested inside Movie clips.

7 Auto label is used to automatically label objects on the stage with the text associated with them. The objects that this applies to are buttons, movie clips and any Flash SWF files that you may have imported.

8 In order for this to work, you must first make sure that you have given them instance names in the Properties Inspector. Names for buttons will be based on any text you have used in your button. Movie clip symbols or SWF Flash files will be based on their instance name.

9 Deselect this option if you would prefer to add your own information to individual items.

10 To add your own information, click on each button, movie clip or SWF file that you might have on your page and add the relevant information in the Accessibility panel.

Adding Accessibility Information to a Button

11 Animation can confuse screen reader software as the content is changing, so select any animation and deselect the Make Object Accessible option.

12 For more information on this issue, go to the Macromedia web site: http://www.macromedia.com/software/Flash/productinfo/accessibility.

Project Management Tips

It doesn't take long for a seemingly simple project to become very complicated. You can end up with many different assets, objects, and layers. The following tips will help you to organize your project efficiently:

1 Always name your layers after what is on them.

In this Animation of a Character Walking, Each Layer is Named
After the Body Part on it. Labels Have Been Added to Blank Keyframes
on a Layer in the Timeline to Mark Key Stages in the Walk Cycle

2 Create a 'Labels' layer and add comments to remind you of key stages in your animation.

3 If you are using lots of layers, simplify your Timeline by using layer folders.

4 If you have forgotten which layer an object is on, turn the visibility on and off – by clicking on the eye icon at the top – for all of your layers until you find the correct one.

5 Keep your Library tidy and keep your assets in obviously named folders.

6 If you have more than one Flash project open you can drag a Library item from one project into the other. Flash will add it to the Library of your current file.

7 **File > Open As Library** allows you to open a Library from another project.

8 At the end of your project, choose **Library > Options > Select Unused Items** and then delete the items that you haven't used.

The Use Count Column in the Library

9 **Library > Options > Keep Use Count Update** shows how many times you've used each item if you scroll through the columns at the right.

10 When working on a complex project use **Movie Explorer. Window > Other Panels > Movie Explorer** shows all the elements in your current scene. The buttons along the top enable you to filter which kind of object you want to see.

11 **CTRL/RIGHT-CLICK** on any of the elements and choose **Go to Location** to find it.

To show Action Scripts

To show buttons, movie clips and graphics

To show video, sounds and bitmaps

To show frames and layers

To show text

To customize which items to show

The Movie Explorer Window

Tips for Lowering File Sizes

When creating web sites with Flash, it is important to try to keep your file size as small as possible – not everyone has broadband. Here are some tips to help you keep your file size down:

1. Animating with **symbols** rather than using frame-by-frame animation will keep the file size down. This is because after you have defined your symbol you are making alterations to them on each keyframe rather than starting a whole new piece of information like you do in frame-by-frame animation. Consequently on each keyframe you are only recording the changes that have been made to

the original symbol. This takes up less computer processing power than with frame-by-frame animation which has new content on each keyframe.

2 Why not set yourself a challenge and try to design a character using only several copies of one symbol?

3 Animated bitmaps are huge! Use them sparingly.

4 Another tip to reduce your file size is to **optimize** all your curves – in other words smooth them out and reduce their complexity. You can do this by selecting a curved shape and **Modify** > **Shape** > **Optimize**. You can modify fills as well as strokes.

5 Softening fill edges takes processor power and the edge has an annoying habit of getting left behind if you move the shape before grouping it with the edge. It is easier on file size to create a radial gradient whose outer edge is the same as the background color of your documents – use the eyedropper to select.

6 The use of gradients can also increase your file size and even the playback speed so keep them to a minimum.

7 Textured lines create a bigger file size so use solid lines where possible.

8 Reduce the number of fonts used as fonts are embedded and make a larger file size. Instead **break apart** text or use Flash **device** fonts. Using these generic _sans, _serif or _typewriter fonts will reduce the overall file size because no additional font info will be saved in the file. This means that the user's default fonts are used – usually Arial, Times New Roman and Courier.

9 The more separate items you have animating at the same time, the more of a strain you'll put on the user's computer – not a problem if you plan to export your work for putting onto video – but not good for the web, so try to plan around this.

10 Use MP3 sound compression – it is the most efficient.

Testing Your Work

Control > Test Movie or **CMND/CTRL + RETURN/ENTER** opens a new window in which you can see a test version of your document at 100% magnification. The test version will loop by default and a temporary version of the document will be exported with a filename based on the filename you have given your document as a **FLA** file.

In this testing environment there are different functions available in the menus.

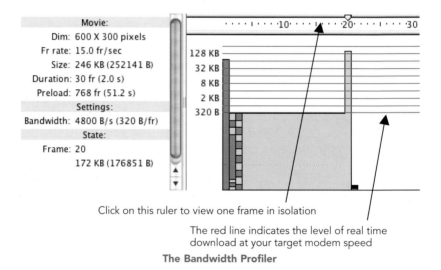

Click on this ruler to view one frame in isolation

The red line indicates the level of real time download at your target modem speed

The Bandwidth Profiler

View > Bandwidth Profiler shows a frame-by-frame graph of the download sizes of each frame.

View > Simulate Download gives you a preview of how long your site will take to load.

View > Download Settings allows you to change the modem speed that you are simulating.

To exit the testing environment, click on the X of your test version to close it – as you would to close any other file.

Anatomy of a Web Site

How is a web site put together and where does Flash fit in?

A web site consists of one or more hyperlinked **HTML** pages located on a host computer known as a **server**. It is accessed through the use of a **browser** program like Netscape or Internet Explorer.

In order to put a Flash document on the web, it needs to be exported in the **SWF** file format and put on an **HTML** page.

HTML is a very basic language, which is not able to do much more than **display** text and page formatting and **link** to other pages and what is sometimes known as 'rich content' – in other words things like sound, video, images, Flash movies or games. Flash movies are used to create more complex content than HTML is able to produce on it's own.

Even though it is possible to create a whole site in Flash, you still need a web page to put this on. The first HTML page that your user comes to is always called **index.htm or .html**. This convention allows the browser program to automatically recognize that this is the first page of your site.

Don't worry you won't have to write complex coding to get your Flash project on the web – web design programs like Dreamweaver or Go Live will do all the hard work for you. You can also get Flash itself to generate a web page that contains your Flash movie.

Exporting

There are several different file formats to which you can export your Flash document. To view the most common options **File > Publish Settings** and then click on the **Formats** tab.

Publish Settings

Current profile: Default

| Formats | Flash | HTML | GIF | JPEG | PNG | QuickTime |

Type:

☑ Flash (.swf) File: yoursite.swf

☑ HTML (.html) yoursite.html

☑ GIF Image (.gif) yoursite.gif

☑ JPEG Image (.jpg) yoursite.jpg

☑ PNG Image (.png) yoursite.png

☐ Windows Projector (.exe) yoursite.exe

☐ Macintosh Projector yoursite Projector

☑ QuickTime (.mov) yoursite.mov

Click here to open a tab for your chosen format
Click here to set the file location
Enter a filename here

Clicking on the **Flash** tab allows you to make choices about the **SWF** file that you will export.

Which version of Flash Player do you think your target users will have? Do you want to protect this file from anyone else being able to import it? Which order do you want your layers to load in?

Be sure to select **Compress Movie** for an optimum file size and enter a **JPEG quality**, which will be applied to any bitmaps you have used regardless of their original file format.

Generate size report exports a text file with details about the effect that different elements have on the overall file size.

Options: ☑ Generate size report

Select the **HTML** tab to customize an HTML page, which will be used to display your Flash document.

 ◄── Click here to open the settings

Detect Flash Version

If you use Flash to generate a web page for you, selecting **Detect Flash Version** will allow you to divert users who do not have the correct version of

Flow Chart

Flash installed. Here's how:

1 If the correct version of Flash Player is detected your user will be automatically taken to your Flash movie. If they do not have it, they will be diverted to an alternative page.

2 Click on the word **Settings** to open the Version Detection Settings.

3 Enter a name for the page that will do the version detection. When you publish this document, Flash will generate a movie called **flash_detection. swf**, which will go on the first page (**index.html** in the example above).

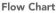

4 Enter a name for the **Content File**. This is the page with the Flash movie on (**page 1.html** in the example above).

You don't have the latest version of Macromedia Flash Player.

This web site makes use of Macromedia®Flash™software. You have an old version of Macromedia Flash Player that cannot play the content we've created.

GET macromedia FLASH PLAYER Why not download and install the latest version now? It will only take a moment.

Macromedia and Flash are trademarks of Macromedia, Inc.

Alternative Page Generated by Flash

5 You have two choices as to where to go if the user doesn't have the correct version of Flash player:

- **Generate Default** will create a page similar to the one in the diagram above.

- **Use Existing** allows you to choose a page that you have created already. This is a good choice if you want to make a site that is truly accessibility friendly. The **alternative** page (**alternativepage1.html** in the example above) could take the user to a simple text-only HTML version of your site either free from any text formatting or using style sheets to format the text while keeping the code clean.

Another important decision you have to make is the size of your web site. In the previous chapter, the issue of different monitor sizes was referred to. If your site has been created in order to be seen on the smallest monitor resolutions – 600 \times 300 pixels – it will seem very small on a larger monitor. There is a way to get round this. Here's how:

1 It is possible to make your HTML page – and the Flash file it contains – **scalable**. In other words, it will change size according to the size of the monitor that the user has.

2 If you take advantage of this scalable option, be careful with bitmap images as then may become pixelated when enlarged by scaling.

3 If you choose **Match Movie** or **Pixels** as the **dimensions**, then the file will have a **fixed** or **absolute** size.

4 However, if you choose **Percent** it will have a **relative** size. In other words, the size will be a percentage of the space in the browser window and not fixed in an absolute pixel size.

HTML Publish Settings > Dimensions

5 The scalability will be effected by the option you have chosen in the **Scale** options:

HTML Publish Settings > Scale

- **Default (Show all)** – scaled in proportion, if window is scaled out of proportion bars will appear at the side.

- **No border** – scaled in proportion, if window is scaled out of proportion the file will be cropped.

- **Exact fit** – if window is scaled out of proportion the file will be stretched or squashed to fit.

- **No scale** – file is not rescaled.

When you have chosen all options required for your Flash and HTML pages, click on the **Publish** button to export an HTML page and a SWF file.

The HTML page or pages can be opened in any web design program and edited.

Creating Pre-Loaders

A pre-loader is a small starter movie that plays while the main site is loading. It should keep your users attention. Pre-loaders can be very complex to create and require a good understanding of ActionScripting.

Here's how to cheat and create a simplified version of your own using **components. Components** are pre-created **movie clip symbols** with scripting attached. They can make life easier for you.

1 You should have already completed your whole web site and exported it (for the sake of this example) as **your_whole_site.swf**. As this example is a cheat, it relies on your web site having a solid background – in other words put a rectangle of color in the background, don't just use the background color of your document as usual.

2 Make a new Flash document. Make sure that it has exactly the same pixel dimensions and background color as in the previous one.

3 Now make a movie clip symbol with a very small piece of looped animation in it. This is what your user will see while waiting. Put it on a layer called **animation**.

4 Make another layer called **loader** and make sure this layer is active.

5 Choose **Window > Development Panels > Components** to open the **Components** panel.

6 Expand the **UI** (User Interface) **Components** and click and drag a **Loader** component onto the Stage.

7 In the **Properties Inspector**, give the loader an instance name like **cmpLoad**.

UI Components

8 Make sure the **Loader** component has the **same** dimensions as your **original** Flash movie web site by entering its pixel dimensions into the **W** and **H** options in the Properties Inspector.

Component	autoLoad	true
cmpLoad	contentPath	your_main_site.swf
	scaleContent	true

W: 600 X: -1.1
H: 300 Y: 2.4

Properties | Parameters

Loader Properties Inspector

9 Then use the **Align** panel to **align horizontal** and **vertical center** with **To** Stage selected – makes sure this is perfectly aligned.

10 Make sure the **Parameters** button is checked in the Properties Inspector.

11 Leave **autoLoad** and **scaleContent** to true. This means that your original site will automatically load into the **cmpLoad** Loader component and will be sized to fit its new container.

12 In **contentPath** enter the name of the original SWF file: your_main_site.swf. This file must be in the same folder as the current document for this to work.

13 Make sure the **loader** layer is above the **animation** layer.

14 Press **CMND/CTRL + RETURN/ENTER** to test.

15 What has happened is that you have created a very small SWF movie that plays an animated loop. Because this loop is within a movie clip symbol it will keep repeating independently of the Timeline.

16 While it is doing this it is also loading your whole site through the use of a Loader component.

17 When your whole site has loaded into the component it will hide the animated loop because the loop is on the layer above.

Uploading

Having now gone through the process of creating and exporting a Flash web site – **how does it get on the Internet?**

Your first step is to buy some **space** on a web server **and** a domain **name**. Buying a domain name on its own does not automatically get you web space. A search on the Internet will lead you to many companies offering free web space and names. When you read the small print, though, you usually have to accept their advertising on your site – you don't get something for nothing.

When you buy a space and a name you will be given a password and details of where on the web to upload your files to – make a note of all this information and keep it safe.

The uploading process is usually done through **ftp** or file transfer protocol. This is just a way of sending files from your computer to a server computer somewhere else in the world.

Web design programs like Dreamweaver or GoLive or simple ftp programs like Fetch can be used for this.

As mentioned earlier in this chapter, a **Flash** document is **displayed** by a **HTML** page.

The **SWF** file that you export from Flash is **linked** to the **HTML** page and not **embedded** within it.

So when you transfer all of the files to the server computer, you need to include both the **HTML** – **container** – file and the **SWF** – **contents** – file.

CROSS-MEDIA PUBLISHING

It is not possible in one little Easy Guide to cover all of the different media that you could export to from Flash. This chapter covers export from Flash to print, video, DVD and stand-alone projectors.

Publishing Profiles

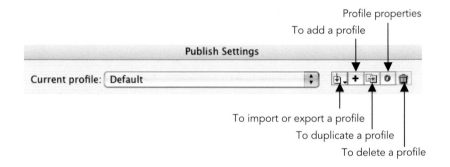

Publishing profiles are a way of saving information about your export options that you can go back to and re-use. When you export for many possible cross-media outputs, you can save a profile in the **Publish Settings** window for each output type.

To create a profile:

1 Select **File** > **Publish Settings** and then click on the **add a profile** button. Give the new profile a name.

2 Then select the formats required and the necessary options for your new profile.

Profile choices

3 You will now be able to select it from the different profiles you have created.

4 If you want to re-use this profile in another document or even share it with a colleague so that can use the same settings, click on the **export profile** button and select **export**. This creates an **XML** file, which can be used in other Flash document.

Exporting Stills

If you want to export individual still images, for example to use as a printed graphic, go to the frame you want to export and then select **File > Export > Export Image.**

If you want to export for print, choose **Adobe Illustrator** as the file type. This will maintain all the vector parts of your image.

It is always good practice to check with your printer exactly which file formats they will accept and what resolution they work at.

Remember to create an extra margin of image, as your printer will need an excess 3–5 mm bleed off the edge for cropping purposes.

Images in Flash are in RGB color, so convert this file to CMYK in an imaging software like Freehand, Illustrator or Photoshop. This is the type of color space used for the print process. You can also add crop marks, if needed, in an imaging software.

Vector graphics are resolution independent. If your printer needs to print from a bitmap format, make sure that you export with a resolution of at least 300 dpi.

Exporting with Audio

In the **Flash Publish Settings**, you can set the quality of audio that you want for streaming or event sounds in an **SWF**.

The audio compression is set to MP3 by default. This is a very effective type of compression and under normal circumstances you can accept the default settings here.

Audio stream: MP3, 16 kbps, Mono (Set)

Audio event: MP3, 16 kbps, Mono (Set)

☐ Override sound settings

Click on the Set Button to Open the Audio Settings

Sound Settings

(OK)

Compression: MP3

Cancel

Preprocessing: ☑ Convert stereo to mono

Bit rate: 16 kbps

Quality: Fast

Sound Export Settings

These defaults will be applied to all of the sounds in your SWF file regardless of the format you imported them in as. So even if you imported them as a **WAV** file, they can still be exported as MP3.

Selecting **Override sound settings** will enable you to attach individual types of audio settings to individual audio files within your Flash movie.

Individual settings can be attached to sound files in the Library. Select the file you want to add individual settings to, choose **Library > Options > Properties** and choose the settings you want to use from the **Compression** options.

Exporting for Video Output

Exporting for video is a matter of **File > Export > Export Movie** and choosing your required file format. The most common choices are **QuickTime Video, AVI, JPEG sequence or Adobe Illustrator sequence**.

The advantage of exporting as a movie file like QuickTime or AVI is that you only have one file to think about and it will also contain any sounds that you might have added. Exporting as a sequence of numbered still images will sometimes give the best quality. Experiment until you find the file format that works best for your particular project.

In Chapter 12, Video, we examined how to create animation with the correct frame rate and size, square pixels, broadcast safe color levels, and all within safe title and action zones.

As we have previously discussed, Flash creates vector graphics. When you export a moving image file format, the vector Flash frames are converted into bitmap video frames. The only problem here is that after this conversion process, sometimes your lines can look **'jagged'**.

The following tips should help you to avoid this:

1. Try to avoid emphatic straight lines at an **angle**.

2. The problem seems to be amplified with strong **color contrasts** between the angled line and the background, so **avoid** this where possible.

3. In your video editing software use a **motion** or **gaussian blur** of around 0.7 to eliminate this.

4. If you have a copy of Adobe After Effects, export from Flash as an **Adobe Illustrator sequence**. After Effects will recognize the sequence of numbered files as a movie and will maintain the vector quality. SWF files can also be imported into After Effects if QuickTime 5 or above is installed on your machine.

5. If you are using Final Cut Pro, export from Flash as a **Version 4 SWF**. Final Cut Pro can import an SWF if it is in version 4 or earlier.

About Compression

Digital video files can be very large. When you export from your Flash **FLA** file into a **QuickTime** or **AVI** movie, you can use compression to keep the file

size down. Compression is basically a mathematical formula that is used to squeeze the maximum amount of information into the minimum storage space.

After you have chosen **File > Export > Export Movie** and **QuickTime** or **AVI** as your file type, then select **smooth** and to **compress video** select a type of **compression** or **CODEC** from the list available.

There will be different choices of compression available depending on whether you have chosen **QuickTime** or **AVI** and also depending on which CODECs are installed on your particular computer.

If you want to put your Flash animation onto video, choose **DV PAL** or **NONE** or the **CODEC that came with your capture card**. It is best practice to take your animation out of Flash at the highest possible quality and then to add compression at the final stage in your editing program.

Make sure the quality is at the **highest setting**. Experiment to see which compression type gives the best quality for your particular project.

Compositing Your Flash Movie

Compositing is the process of combining computer-generated animation with video. This can be done by importing video into Flash and creating animation on layers above the video clip.

However, you may wish to do this in an editing or post-production

Flash Animation Combined with Video in After Effects

program, which has many more tools for working with video.

In order to seamlessly combine animation with video, it is best to create a sequence of animation with a transparent background.

The easiest way to do this is to export an Adobe Illustrator sequence to After Effects. All areas of the original in which the background color of the document were showing will be automatically transparent in After Effects. You get the same effect if you export a PNG sequence from Flash and take it into After Effects.

How did that Work?

The areas that are transparent were recorded in an **alpha channel**. This is a channel of information contained in the file about transparency. Only certain file formats and certain types of compression can contain alpha channels.

If you want to create transparency in a QuickTime or AVI file, it is a slightly more complex process:

1 Go into the **Color Mixer** and make a color with 0% Alpha.

2 From the **Color Mixer options** choose **Add Swatch** and the transparent color will be added to the **Color Swatches** panel.

Transparent color swatch

3 This transparent color can now be chosen as the background color for the document in the Properties Inspector or by choosing **Modify** > **Document**.

Exporting a QuickTime with an Alpha Channel

4 Export as a **QuickTime Video** with **Animation** compression and **32-bit color (alpha channel)**. The PC equivalent is to export as a

Windows AVI with a type of compression that can support alpha channels and is loaded on your system – like **Indeo Video** compression – and **32 bit color (alpha channel).**

5 This file can now be taken into a video editing program and alpha channel transparency can be utilized.

Putting your Flash Movie onto Video or DVD

As previously discussed, follow these stages to put Flash animation onto **video**:

1 Create animation in a Flash document with the correct frame rate and square pixels frame size for the region in which you live – NTSC, PAL or SECAM.

2 **File > Export > Export Movie** and chose a file format compatible with your video editing program.

3 Take this movie into your video editing program.

4 Use the video editing program to record the animation onto tape.

Putting Flash animation onto **DVD** is a slightly different process.

A DVD consists of **MPEG** video files, **menu** and **navigation** information woven together in a process known as **multiplexing**. All of these files must be created and stored with the correct conventions in order to be read on a DVD player.

You can't create files directly out of Flash that will play on a DVD player straight away.

If you are working on a **Mac** export **QuickTime** movies from Flash. Bring these into a DVD authoring software like DVD Studio Pro or iDVD. These will create MPEGs and DVD menu structures for you.

If you are working on **Windows**, Adobe Premiere will accept AVI or QuickTime movies. You can use it to create MPEGs and author basic DVDs. You can also bring either AVIs or MPEGs into Adobe Encore to create DVDs with more complex menu structures.

Exporting Projectors

Projectors are standalone applications that do not require the user to have Flash Player installed on their machine. They are useful for authoring CD-ROMs and emailing. You will need to create one version for Mac and one version for Windows users.

Be aware that projectors are bigger in file size than SWFs.

Choose **File > Publish Settings** and select **Windows Projector (.exe)** and **Macintosh Projector** in the **Format** options. There are no options to customize in the **Publish Settings** for projectors.

If you want to create a CD-ROM that will automatically open on a PC, here's how:

1 Publish a **projector** file from Flash, for the sake of example let's call it **myprojector.exe.**

2 Open up a text program like Notepad and type in:

```
[autorun]
open=myprojector.exe
```

3 This will automatically open your projector file when the CD is inserted.

4 Save this text file as an "All Files (*.*)" and name it **autorun.inf.**

5 Burn your CD-ROM with the **autorun.inf**, and projector file in the root directory of the CD.

6 Unfortunately, this will only work on a PC and not on a Mac.

Creating a Hybrid CD

If you want to create a CD that will play on both Macs and PCs, first export both a Mac and PC projector. Then make sure that your CD burner can burn it as a **hybrid** CD, which will open on both platforms.

Web usage statistics

Nielsen/Net rating: http://www.nielsen-netratings.com
The Counter.com: http://www.counter.com
Macromedia: http://www.macromedia.com/software/player_census/flashplayer/

Web design info

Jakob Nielsen, the usability guru: http://www.useit.com
Web Monkey: http://hotwired.lycos.com/webmonkey
Web Design Guide: http://www.dreamink.com

Accessibility

Worldwide Web Consortium: http://www.w3.org/WAI
Macromedia: http://www.macromedia.com/macromedia/accessibility/

More about mobile devices

PocketPC: http://www.pocketpcflash.net/home.htm
Macromedia Mobile Devices site: http://www.macromedia.com/devnet/
devices

Sound resources on the web

Free loops: http://www.flashkit.com/loops/
Free sound FX: http://www.flashkit.com/soundfx/
Free loops and FX: http://www.samplenet.co.uk
Not free: http://www.soundoftheweb.net/
Not free: http://www.media-tracks.com

ActionScripting tutorials on the web

Flash Kit: http://www.flashkit.com/tutorials/Actionscripting/
Actionscript.org: http://www.actionscript.org/
Flash Guru: http://www.flashguru.co.uk/tutorials.php
Kirupa.com: http://www.kirupa.com/developer/actionscript/index.htm

Flash animation tutorials on the web

Macromedia: http://www.macromedia.com/support/flash/design_animation.html
About Animation: http://animation.about.com/cs/flash
Flash Film Maker: http://www.flashfilmmaker.com/
Flash Kit: http://www.flashkit.com/tutorials/Animation/

Animation resources on the web

Animation World Network: http://www.awn.com
What you need to know about animation: http://animation.about.com/

Further reading on character animation

Blair, Preston. (1994). **Cartoon Animation**, Walter Foster Publishing.
Whitaker, Harold and Halas, John. (2002). **Timing for Animators**, Focal Press.
Williams, Richard. (2001). **The Animators Survival Guide**, Faber and Faber.

Further reading on motion graphics

Curran, Steve. (2001). **Motion Graphics**, Rockport Publishers, Inc.
Goux, Melanie and Houff, James A. (2003). **>On Screen>In Time**, Rotovision.
Hall, Peter and Codrington, Andrea. (2000). **Pause: 59 Minutes of Motion Graphics**, Universe Publishing.
Woolman, Matt and Bellantoni, Jeff. (2000). **Moving Type**, Rotovision.

Further reading on Flash

Lever, Nik. (2002). **Flash MX Games**, Focal Press.
(New edition due on Flash MX 2004 June 2004 – **Flash MX 2004 Games**)
Michael, Alex. (2002). **Animating with Flash MX: Professional Creative Animation Techniques**, Focal Press.
Michael, Alex. (2003). **Understanding Flash MX 2004 ActionScript 2.0**, Focal Press.

Index